B

How to evolve from the garden paintings at Arken... or just make a big leap. — ... more studio oriented now. ... I ...

That seemed into them. The ... of? Am I just lazy? NO — there were reasons for ... to those paintings — small studios mainly. Controlled space ... that I have the studio space is a far larger space outside. ... more exposure to control with paintings? But here I can ... through the winter.

I know I'm wanting to get the personal — ... psychological — penetrative into the work — like "Spring" ... is not here yet. These paintings now — pond, rose garden, ... are lovely & visually compelling but don't have deep meaning for me. Paint a rose into everything? Pain... ... — the moon gardener?

I like it when the painting has a skin. Memory. Suge... ... what's been before. Traces. But not just much. Strange...

What are the roses? Dancers. Me a dancer in the garden...

Beauty. Fleeting. changing. Promises.

A PAINTER'S GARDEN

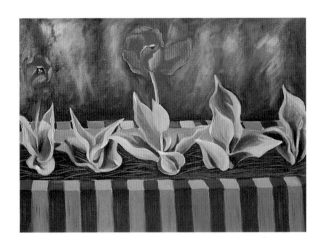

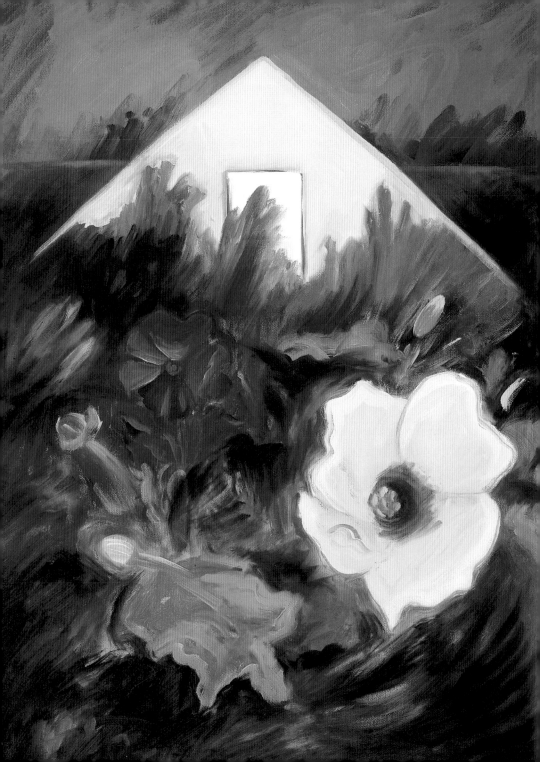

A Painter's Garden

Cultivating the Creative Life

CHRISTINE WALKER

WARNER ⓦ TREASURES®
PUBLISHED BY WARNER BOOKS
A TIME WARNER COMPANY

For my family and friends—in appreciation

Text, paintings, and drawings
Copyright © 1997 by Christine Walker
All Rights Reserved.

Warner Treasures® name and logo are registered trademarks of
Warner Books, Inc.
1271 Avenue of the Americas
New York, NY 10020

Visit our Web site at http: //pathfinder.com/twep

W A Time Warner Company

Produced in association with Compass Rose Productions
Editorial Direction: Catherine Kouts
Art Direction: Christine Walker
Design: Susan Bercu
Production: Lynn Bell and Linda Hauck
Publication Design & Production

Printed in Hong Kong

First Printing: October 1997
10 9 8 7 6 5 4 3 2 1
ISBN: 0-446-91208-5

Grateful acknowledgment is made to the following for permission to print copyrighted material. Every effort has been made to contact the original copyright holders. RICHARD RODGERS AND OSCAR HAMMERSTEIN lyric excerpts of "Happy Talk" (p. 4), copyright © 1949 by Richard Rodgers and Oscar Hammerstein II. Copyright renewed WILLIAMSON MUSIC owner of publication and allied rights throughout the world. International Copyright Secured. ROBERT FROST excerpt from "The Road Not Taken" from *The Complete Poems of Robert Frost*, published by Henry Holt and Company, Inc. GEORGIA O'KEEFFE and GERTRUDE STEIN quotations courtesy Yale Collection of American Literature, Beinecke Rare Book & Manuscript Library, Yale University. EMILY DICKINSON "To make a prairie..." Reprinted by permission of the publishers and the Trustees of Amherst College from THE POEMS OF EMILY DICKINSON, Thomas H. Johnson, ed., Cambridge, Mass.: The Belknap Press of Harvard University Press, copyright © 1951, 1955, 1979, 1983 by the President and Fellows of Harvard College. T'AO CH'IEN "The trees after a sharp wind" from *The Poems of T'ao Ch'ien* translated by Lily Pao-Hu Chang and Marjorie Sinclair, copyright © 1953 by University of Hawaii Press. WU-MEN "Ten Thousand Flowers in Spring" from *The Enlightened Heart* by Stephen Mitchell, copyright © 1989 by Stephen Mitchell. Reprinted by permission of HarperCollins Publishers, Inc. RUMI "Birds make great sky-circles" from *The Essential Rumi* translated by Coleman Barks, courtesy Threshold Books, 139 Main Street, Brattleboro, VT 05301. PATTI TRIMBLE "Rose" copyright © 1997. CARL SANDBURG excerpt from "Lesson" in *Honey and Salt*, copyright © 1963 and renewed 1991 by Margaret Sandburg, Helga Sandburg Crile, and Janet Sandburg, reprinted by permission of Harcourt Brace & Company. WILLIAM CARLOS WILLIAMS excerpt from "The Act" from *Collected Poems 1939–1962, Volume II*, copyright © 1948 by William Carlos Williams. Reprinted by permission of New Directions Publishing Corp. PHILIP GUSTON quotation from "Faith, Hope and Impossibility," XXXI ART NEWS ANNUAL, 1966, copyright © 1965, ART NEWS.

CONTENTS

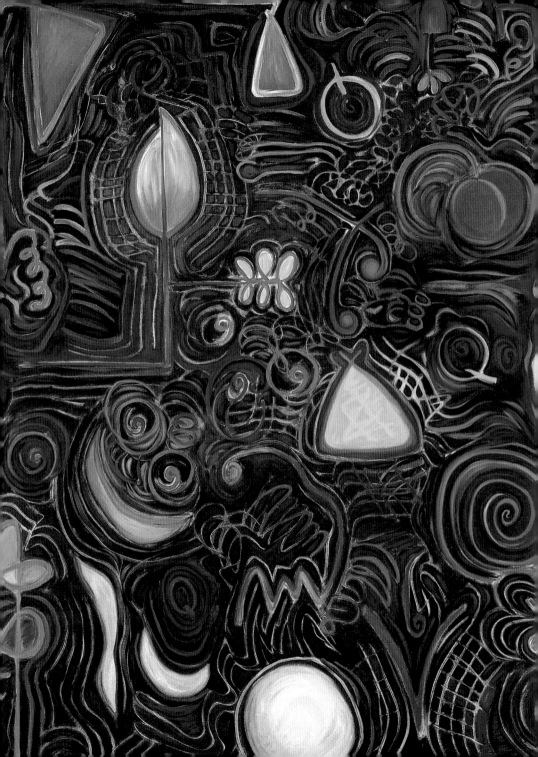

GIFTS FROM THE GARDEN

A letter to a friend has grown into this gift of images and words—a present wrapped with the insights and encouragement my garden has given me. On opening, it reveals the joys of living a creative life and coming to terms with one's gifts and limitations.

Many years ago, I imagined a place surrounded by nature to grow a family and do creative work, hoping to fulfill that dream within five years. It has taken eighteen. As I write this, I am living the life I visualized as an artist, a mother, and a partner to a wonderful man. We live and work at home in the country. A friend's offhand comment led me to reflect on how I found my way to this place. On the phone one day, Amy said to me, "You're living your dream! How did you make it happen?" Her words settled into me and nudged out questions: What is it that sets one on a creative path and keeps one pushing forward in spite

of entanglements? What steps must we take to fulfill the promise of our intentions? In other words, how do we make our dreams come true?

It's not enough to dream, although it is necessary to have a clear vision. Parents and teachers praise hard work, but many of the wise advocate effortlessness. Faith ranks high, but one's faith is always tested. Good luck counts, but not without the bad, because that often heralds good fortune. Talent, knowledge, and skill in one's chosen field are required, but naïveté and an openness to learning sometimes bring profound insights and a wealth of good ideas. Regardless of the paths we take, getting "there" never ends up being exactly where we think it is going to be. Creativity is not a simple step-by-step process, but a cycle. Much like plants need the seasons, we need to establish and feel creative rhythms that let us root and flourish, lie fallow, and bloom again. Whether making paintings, writing songs, or growing a business, it is the creative life that is being formed, not just the products of our hands and minds.

I began cultivating a garden to have subject matter for my paintings. Now the garden more than inspires my art; it offers me, daily, a way to grow and change. One afternoon, while shoveling turkey manure, I realized how much the act of gar-

dening is a metaphor for the creative process. As a gardener, one is always learning from nature, the great teacher, who says it's okay to be out of control, a little confused, a tireless worker, and a reflective spirit. In the garden, one may make mistakes and not be too oriented toward results. However, for the garden to flourish, tasks must be tended to every day or so throughout every season, and we must notice what's going on. We may have ideas about how we want our garden to be, but it tells us quite clearly how it intends to grow. In nature's hands and our own, matter is changed from seed to plant, compost to flower and fruit. Gardeners have faith in transformation, in return for which we receive the gift of seeing a little more today than we did yesterday.

As I continue on the journey reflected upon in this book, becoming a more accomplished artist and learning each day the joys and perils of an interior life expressed through an artistic form, I thank the garden for the way it nourishes my art and renews my spirit. I hope the following essays and journal excerpts offer you companionship as you travel your creative path. And, as much as possible, I wish all of us bountiful gardens to contemplate in solitude and celebrate in friendship with one another.

Gardeners and artists have faith in transformation,
in return for which we receive the gift of seeing
a little more today than we did yesterday.

A YARD
OF
ONE'S OWN

Happy talk,

Keep talkin' happy talk,

Talk about things you'd like to do.

You gotta have a dream,

If you don't have a dream

How you gonna have

a dream come true?

OSCAR HAMMERSTEIN II

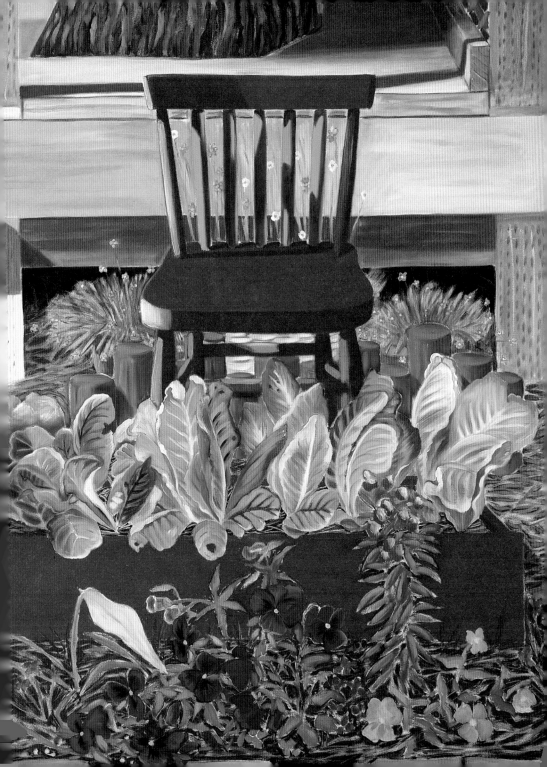

ONE SMALL POT

There is a Chinese folktale my son and I love to read together. An elderly emperor has no heirs and announces that he will give his kingdom to the child who can grow the most beautiful flower. Each child receives a seed and races home to plant it in a pot. One little boy, Ping, is sure his flower will be the best. He tends his potted seed faithfully, but nothing grows. The children return to the palace with their lovely flowers. Ping is ashamed of his empty pot. His father encourages him, "You have done your best."

As the emperor surveys the crowd of children holding their pots full of lovely flowers, he frowns. Finally the emperor confronts Ping, who tells the emperor that he tried hard but the seed just wouldn't grow. The emperor warmly embraces Ping. He announces to the others that he had cooked the seeds and that only Ping is courageous enough to appear before him with an empty pot. He makes Ping emperor of his kingdom.

When we take on the task of doing the best we can within whatever limits we face, there is often a rich reward. The results of our efforts may surpass our expectations or may take a form so unlike what we anticipated that we recognize them only belatedly as our prize. Starting small with whatever resources are at hand works for most endeavors—writing a book, growing a business, learning to cook, making art. If there is no land for a garden, grow a flower in one small pot and see what happens.

In my early twenties, I took a drawing class from a wonderful artist and teacher at the Kansas City Art Institute. I had a full-time

teaching job and worked additional hours in the evenings and on Saturdays for community art programs. My resources were limited because I was helping my first husband through law school. I was frustrated by having so little time to draw or paint and no studio or extra money for art supplies. By taking Michael's class, I guaranteed myself a few hours a week devoted to drawing. He introduced me to a method of working that has kept me making art over the years, even during difficult times.

He told me to work small enough to complete a drawing in whatever time I had available. For subject matter, he suggested I use whatever was convenient—my name in script, for instance. I began using colored pencils to make six-inch-square drawings on white paper, working from shapes found in my signature. I would arrive home from teaching, sit on the couch, and draw. If I had only a few minutes and couldn't complete a six-inch drawing, I'd divide the square into grids and make one-inch-square drawings. Gradually,

the drawings demanded more from me, and somehow I found the time to give to them. Working on a card table in the living room, I made two-foot-square drawings that took weeks of evenings and Sundays to finish. I stole time to work on them. The shapes derived from my signature evolved into marks and symbols inspired by classical music I listened to while I drew. As the drawings became more dense and layered, I experimented with other materials, finally settling upon layers of Plexiglas painted with acrylic and held together by frames I designed and had fabricated. One of those paintings was my first piece exhibited in a museum show.

Over the years, I have returned to working small and within limits imposed upon me or defined by me. This invariably leads to new insights and eventually produces a strong series of work. The "start small" method is easy to do. You just begin.

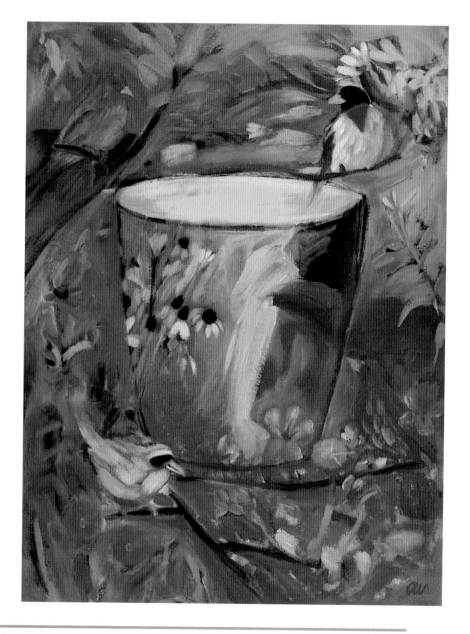

Starting small with whatever resources are at hand works for most endeavors—
writing a book, growing a business, learning to cook, making art. If there is no
land for a garden, grow a flower in one small pot and see what happens.

CLAIMING THE TERRITORY

Two roads diverged in a yellow wood, and sorry I could not travel both and be one traveler..." I sang these words by Robert Frost in chorus at my high school graduation. In the years since, they have served as a compass for my journey. We each have an internal landscape that guides us in our choice of which path to take. Call it intuition, soul, or logic, that sense of direction can serve us well at crossroads. The map to the territory we are exploring has not been charted; we do that as we go along. We choose a path and follow it, but rarely does it roll out ahead of us smooth and straight. It loops, widens, narrows, and bends in the undergrowth.

Much of the time, my path has been wide, allowing me to move freely among several disciplines. Each has enriched the other. Occasionally, I have had to take a narrower path and leave something behind. At those times, I picture the yellow wood, and map a careful route so that at the end of the journey, I will have traveled as a painter.

When I was twenty-seven, teaching and painting in Kansas City, I planted a small garden in my backyard. One day I harvested the entire crop of peas and potatoes for a single delicious meal. The next summer I moved to San Francisco and didn't grow a garden again for fourteen years.

I had been divorced and was now remarried. My husband, Dennis, and I lived in a third-floor one-bedroom apartment. I painted in a warehouse

loft above a fortune cookie factory. My
feet touched concrete more often than
earth. Whenever possible, I ventured into
the country to make sketches, pho-
tographs, and watercolors to use as source
materials for large oil paintings. The paintings
reflected landscapes, waterfalls, oceans and lakes, mountains,
and trees. If they included figures, it was of people such as
swimmers and pedestrians immersed in their environments. I
moved disjointedly between studio, office, and home. I ran a
graphic design business and collaborated with choreographers in
theater design. Dennis and I were partners in a music production
business, writing songs together and marketing a series of audio-
tapes for children. And, after years of trying, I finally became a
mother. My path was widening and I was my own Sherpa, bal-
ancing many loads and loving the trek.

I then reached a critical junction. I lost the lease on my spacious
rent-controlled painting studio of thirteen years. To anyone unfa-
miliar with San Francisco's soaring real estate market this may
sound like a molehill; to me it was a mountain set squarely on my
path. I would have to climb it or seek another way to juggle busi-
ness with motherhood, keeping painting in the balance. Our small
apartment couldn't hold my painting supplies, much less one more
activity. I needed a place to paint.

On a cold and sunny January day, my sense of direction took
me to the top of Potrero Hill, an urban neighborhood with a view

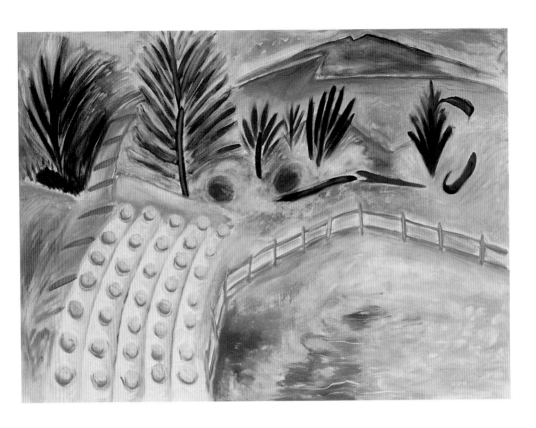

of the city's skyscrapers and freight barges docked in the bay. There a white frame house stood waiting to be rented. It was run-down inside but livable, with ample storage in the basement for my stacks of canvases. Through the kitchen window I saw a dilapidated garden and a little peak-roofed shed at the back of the yard. A painting studio! All the voices that inhabit my internal landscape screamed... "We'll take it!" For the first time in my adult life, I felt I could stake a claim. The morning light, the doves, and an old pine tree towering over the shed sang in harmony with my interior voices. The yard was cluttered with debris from former tenants. A

bedraggled rosebush and a shiny green lily plant were the sole occupants of an old flower bed. Broken concrete steps and a few patches of poor soil formed the bones of the garden, but it was enough.

I had occasionally painted gardens as a visitor to public parks or a friend's backyard. After our son, Quinn, was born, my painting time was limited and I made fewer trips to the country. Instead, I painted cut flowers in my studio. Now I knew I would grow my own garden and paint it. This spot of urban nature with its studio shed was a resting place on my path through the yellow wood. Another potential renter walked the house and garden with me that January day and looked on the neglected place with disdain. Perhaps she wasn't as desperate as I was. I saw only the quality of light and the potential for beauty. Luckily, she moved off in another direction and I claimed the territory for painting. When we moved in and I began to grow the garden, my internal landscape blossomed.

We each have an internal landscape that guides us in our choice of which path to take. The map to the territory we are exploring has not been charted; we do that as we go along.

A FERTILE PLACE

One morning three-year-old Quinn came down to breakfast, looked out into our enclosed urban backyard, blinked, and exclaimed, "Mommy, you've been painting all night!" I followed his gaze to the easel standing in the garden. I'd forgotten to put it away from the previous day's work. What a wonderful idea! Could I paint all night? Paint the tree silhouetted against the moon, the flowers dimly lit by the bare porch bulb? Wave my brush as if in a dream, not seeing what I was putting down on canvas? At the moment Quinn spoke, an old longing slipped away. I recognized that I was where I had always wanted to be, firmly planted in a fertile place designed by my desires.

Years before, while I was living in Kansas City, I had been given an exercise by my friend Gerard to help me plan a life in which I could realize my ambitions. At the time, I was discontent. I was drawing, painting, and photographing, but had not yet figured out how to make these pursuits my profession. One of Gerard's worksheets asked that I picture a day five years into my future and write it all down in detail. My imaginary day was glorious; nature surrounded me. I was on a deck behind a house with a view of trees and a creek. The locale was northern California. I sensed the presence of a husband and children in my life, but no one else inhabited my dream at that moment. I was confident in my profession, which involved some kind of artistic work. Although I wasn't clear exactly what that was, it satisfied my creative intentions. I knew my workday would be spent in solitude, but the cul-

tural life of a city was within reach and family and community were an important part of my imagined life.

As I fixed Quinn's breakfast, I looked out the kitchen window at the close approximation of my dream. At the rear of the yard, the studio was full of paintings depicting the flowers and furnishings of the garden. I could see the canvases now, their colors lit by the morning sun. A deck, which my dad and Dennis had built, fronted the studio. There was the old pine tree, but no creek. Birds sang and the neighbors' flowering shrubs peeked over the fences. My husband and son were nearby and the city hummed in close proximity. Many more years than five had passed, but I felt no loss, only gratitude.

My gaze rested on a red chair sitting in a flower bed. I had painted chairs, fences, sticks, and pots with bright colors and placed them here and there to distract the eye from the drab concrete that filled more than half of the yard. These painted props played roles in my paintings and kept the garden bright even through the rainy winter months. I continually redesigned the garden for painting with potted plants and annuals bought on fre-

quent trips to the nursery. The red chair appeared in several paintings, symbolizing a human presence contemplating the surrounding garden. I had been studying Persian miniature paintings, attracted by their beautifully detailed representations of enclosed gardens where lovers lounge in gazebos, musicians play, and women bathe in pools. The word "paradise" derives from the Persian word for garden—*paradeiza*—a symbol of eternal life. My paintings, although of a much larger scale, also depicted a carefully cultivated oasis within an enclosed space.

For several years the little urban garden gave me a focus for my painting. I was juggling the joys and demands of motherhood with running my design office, collaborating with Dennis on children's songs, and building our music business. We had great hopes for our projects, but we were facing a particularly difficult time financially and emotionally. One day Dennis and I sat down together and drew a picture of our life design, writing at the top "What we want it to look like." We drew a simple outline of a house with Dennis and me and two children inside. A path led to a garagelike structure with a window-walled painting studio at one end. Another path led to a peak-roofed cottage and a sign that announced RECORDING THAT-AWAY. Around the sketch, we scrawled lists of what we hoped to have in our lives and what we wanted to eliminate. Nature figured prominently in our desires, as did more time for making art and music, good health, and freedom from stress and worries. We tucked the drawing away in the file cabinet and continued on with our work.

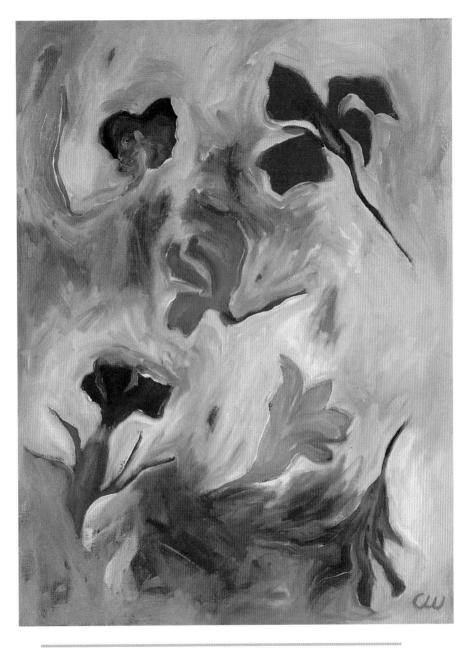

*Dreams do respond to our desires when those desires are clearly
defined and allowed to manifest in their own time.*

17

A year or so later some of our hopes and dreams began coming true. Our children's music business flourished. We signed contracts to develop products based on our songs and a character we had created. Dennis began composing a successful audio series combining natural sounds with music. I was able to close my graphic design office and concentrate on painting. As much as I loved the urban garden, I needed bigger spaces to explore. I was painting myself into a corner in our little backyard. I wanted to push out into the landscape.

On and off for two years, we searched for an affordable place to live that suited our needs and desires. One day we answered a rental ad and drove an hour north of San Francisco past rolling hills and apple orchards to a single-story frame house surrounded by a lovely, well-established garden. The current tenants showed us the house and then led us out the kitchen door, across the back deck, and through an ivy-covered archway to a detached three-car garage with potential for renovation into a painting studio. From the driveway, another hedge of ivy arched over a brick path leading to a peak-roofed pale yellow cottage. We immediately felt at home and knew we wanted to live there. In our unpacking after we moved in, we unearthed the life design drawing and saw how clearly the place resembled our sketch.

I set the red chair in the new garden, but I never painted it again. The garden's architecture immediately began shaping my thoughts, but it took several months to understand how I wanted

 to paint in these new surroundings. In the city, I had created an environment of plants and objects to paint; here a world was offered to me. I could no longer change the various beds at my whim, because most of the garden was planted with established perennials. I moved a pot here or there, added a few annuals, and soon realized that nature was in control, not I.

The country garden and landscape of Sonoma County serve as inspiration for my paintings and feed our creative spirits while nourishing our family life. My imaginary day has served as a blueprint for my present life. When Dennis and I sketched our life design, we elaborated on a dream that was compatible with his own. Reality has filled in the details. The fertile place of my imagined future has fully materialized. We've hung the drawing on our wall as evidence that dreams do respond to our desires when those desires are clearly defined and allowed to manifest in their own time.

PREPARING THE SOIL

My center does not come
from my mind—
it feels in me like a plot
of warm moist well-tilled earth
with the sun shining hot on it—

GEORGIA O'KEEFFE

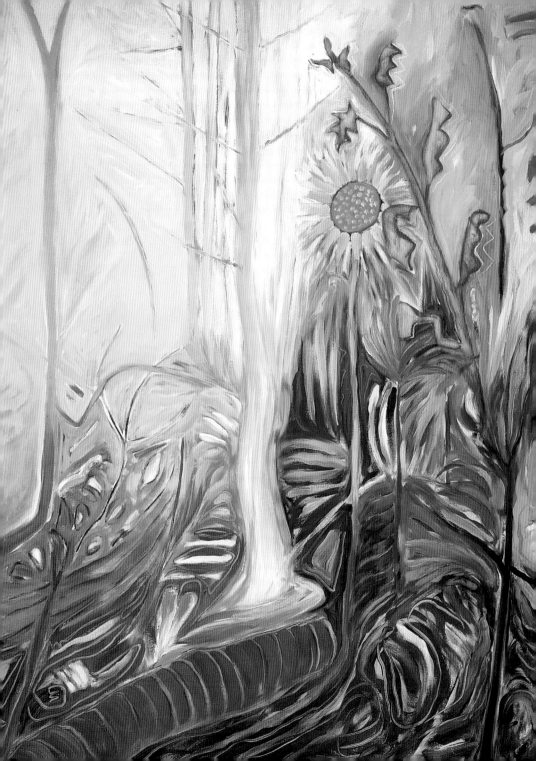

LOVING YOUR DIRT

Gardeners care about dirt. They trade soil tips like stock advice. If you meet a fellow gardener, a complete stranger, at a gathering, he will soon be telling you about his horse manure, how it makes his boysenberries thrive, and where you can get it for free. The more I learn about gardening, the more I love dirt, but it didn't happen right away. When I put in my little garden on Potrero Hill, I didn't know anything about soil amendment, pH levels, clay or sandy qualities, or composting. Impatient, I wanted to get colorful flowers growing and plant some lettuce and arugula in a patch of earth about four by eight feet. My friend Maureen, a longtime gardener, said we should till the area and amend the soil. So we rented a heavy tilling machine and attacked the hard ground. Another good friend and gardener, Carol, brought me a bucket of chicken manure. She had a direct source because she raised chickens in her city backyard. I mixed the manure into the dirt, wanting to hold my nose, but not being able to because my hands were covered with the gooey, stinky stuff. Now, as I write this several years later, I know the value of Carol's gift. I wish I still lived close enough to be the recipient of an occasional bucket of her hot manure to help cook my compost. But in those first years in my urban garden, I wasn't yet familiar with the riches of composting. When my soil looked depleted, I purchased bags of live earth at the nursery to pour into planting pots or sprinkle on the flower beds. From time to time, I'd throw a sack of store-bought composted manure onto the soil and work it in with a spade. Looking back, I

realize I didn't care enough about dirt then to qualify as a true gardener. Gradually, I've learned to love it.

Dirt is where it all begins. Whatever endeavors we undertake, there must be fertile ground in which to grow them. So we mine our earth, hoping that there is enough stuff of significance in our backgrounds in which to root the work. The fear is always there. Will I come up short? Will I run out of ideas? Is my history, my childhood, maybe even my soul adequate enough to support the richness I hope to achieve in my art? Gertrude Stein said, "Painters do not paint the colors that their eyes see, they paint the colors of which they themselves are composed. Certainly it is not what anybody else sees. They use their eyes in order to paint what they know."

I've worried that the raw material of my life might be insufficient. My background feels uneventful. Second in a family of four children, raised by loving parents in a midwestern suburban community, I picture myself as a gangling girl with large hands and feet. Reaching back, I examine my childhood for clues to an adult life shaped by a love for nature and creativity. My older sister and I outlined houses with grass clippings on the lawn, then acted out dramas in those rooms. On freezing winter days, we skated on ice made by our dad with spray from a garden hose. Searching for tunnels to China in our backyard, we found dark holes lined with soft brown earth and waited expectantly for rabbits or crawdads or a mysterious creature to appear. As children, we gravitated toward sticks and stones, sand and water, leaves, grass, and dirt.

Assessing my resources, I weigh my past and honor the way it nourishes me today. The present is rich in meaning and detail. The future is full of possibilities. All of this is my earth, in which to grow a creative life. Sometimes when I'm painting or digging in the garden, a moment out of time comes breezing by and tickles my memory. I look and listen, smell and taste. I touch it and the moment crumbles, leaving a trace of dirt on my fingertips.

Whatever endeavors we undertake, there must be fertile ground in which to grow them. So we mine our earth, hoping there is enough stuff of significance in our backgrounds in which to root the work.

25

Feel I'm getting closer to that thing that is
in me— I've been close before. It's about
transformation. That's all of what painting
is for me. The desire to transform the stuff
of my life to something beautiful, magical, powerful.
Take this garden. The effort to create beauty
in this run-down, unassuming space. It's fleeting.
Not permanent like the paintings. But the desire
to paint it is to transform it again through my hand
and keep a trace of its beauty in my life.
I love how things look. Light. Shadow. Color. Form.
But want to get at what's under the surface—
my connection to the visual through my body—
not just my eyes. And to tell a story— relate a moment.

GARBAGE HEAPS

Warming up to the idea of throwing garbage into a pile in my backyard took time, but the best gardeners I knew raved about their compost piles, so I decided to join their ranks. While still living on Potrero Hill, I signed up for a workshop given by SLUG, the San Francisco League of Urban Gardeners. Their illustrated brochure shows compost enthusiasts how life might be enhanced by black-plastic compost cookers, chicken-wire bins, and cardboard boxes filled with worms. (I knew my five-year-old would be intrigued by the worms.) On a damp and chilly November morning, I took Quinn with me to SLUG's headquarters on 7th Avenue, where a shivering group of aspiring composters was gathered on wooden bleachers in the garden.

The instructor introduced himself and then carefully held out a handful of compost. It looked like black earth. We passed it reverently from person to person. He asked us to guess how many living organisms were in that handful. A thousand? A million? Sixty-seven? (Quinn was just learning his numbers.) No, this tiny heap of compost was teeming with more organisms than all the humans living on earth. It contained billions of creatures who spend their invisible lives in the soil and make our gardens grow. I stared at the compost in my hand, felt its weight, and tried to imagine the busy microscopic workers who lived there. At that moment, I began to think about dirt in a different way and started dreaming about a larger garden with a big compost pile.

A year and a half later, we moved to our home in the country. For the first time I was living in a house with a garbage disposal. Yet we have a bucket in our sink to collect garbage. The fruit peels and vegetable scraps, coffee grounds and filters, tea leaves and eggshells pile up. When the bucket is full, I take it out to a spot near the raised vegetable bed where the compost pile awaits. Simply designed, made of wood posts and chicken wire, the compost is divided into three bins and has a movable wire screen on top for sifting. I toss the smelly, slimy contents of the bucket onto the pile of rotting garbage in the first bin. Underneath the top layers of still-recognizable garbage, something magnificent is happening; it is becoming what my friend Kimi calls "black gold." After months of turning it over with a pitchfork, letting it rot, and turning it again and again, I sift it into the second bin, separating out the big hunks, then sift it again into the third bin. Rich black compost softly falls through the screen into a pile, ready to use. From a soggy heap of garbage, I harvest a small hill of sweet-smelling dark earth. When I amend the soil in the vegetable bed, mixing the crumbly compost into the dirt in my bare feet, feeling it press softly between my toes, I reap my reward for the countless trips through the winter rain with the kitchen bucket. In time, the garbage-become-earth makes my lettuce tastier.

As an artist I am always amending the fertile soil in which I grow my ideas. Often what seem the most inconsequential, mundane, certainly the least inspiring incidents of my life just have to

sit awhile and simmer before they are ready to use. Some things remain impervious to examination for years. In the way an old, hard orange sits on the compost pile refusing to break down, a past experience insists upon staying a hard lump in the memory stew. But over time, or through intervention that splits the tough outer shell, the experience breaks down into something juicy I can use.

My artistic compost pile is fed from many sources. A heap of biodegradable material is brewing in the journal/sketchbooks I have kept for twenty-five years. In these books, I deposit an assortment of ruminations and examinations, groans and grievances, elations and devastations, clear-eyed observations and offhand gestures. I periodically forage through them for renewed inspiration and better understanding of my ideas and processes. I have no system for keeping these journals; I get hardbound or paperbound blank

books and write or draw in them as often as I can. The journals serve to jog my memory, but the nutrient-rich material is in me, deposited there while reading, watching movies, talking to friends, taking walks, enjoying dance, listening to music, traveling, and working in the garden. It's also the residue of flat tires, junk mail, arguments, and illness. I don't always know what's going into the heap, but when I reach for something within, I find a new richness that comes from the layering of days and events in which I was fully present, but unaware of the significance the moments might later give.

Often what seem the least inspiring incidents of life just have to sit awhile and simmer before they are ready to use.

EXCAVATIONS

The small garden next to the deck of my painting studio is slowly sinking. It is constrained by the concrete driveway on two sides, the deck on a third, and a retaining wall on the fourth. Gophers tunnel under the driveway to reach the flower bed. Perhaps the soil is washed out through these holes or maybe it is escaping out breaks in the retaining wall. As the garden settles, we are settling in. We're becoming part of this country garden's evolution.

When I first dug out the bed, the soil was hardpan. It resisted my shovel. On the advice of other gardeners, I soaked the earth with water. After the pooled water had sunk into the earth or evaporated, I would soak the bed again. This process continued for several weeks. With Dennis's help, I was eventually able to dig down two feet.

As I dug, I uncovered evidence of past lives lived here on this remaining acre of what was once a much larger farm. The original farmhouse, contained within our remodeled home, was built in 1914. The small bed may once have been part of a larger garden, before the garage was built and the concrete driveway laid. The first few inches of excavation produced dirt dotted with small rocks and a few golf balls. Then I hit a clay pot graveyard. Shards, slivers, and rims of clay pots randomly patterned the soil. I dug deeper, imagining the families who have lived here. A tarnished soup spoon appeared. I pictured a child digging in the dirt with it or dropping it during a backyard picnic.

Digging deeper, I unearthed shells. Then I found my treasure—a piece of ceramic an inch in diameter with a lovely robin's-egg-blue veined glaze. It's a worthless piece of clay, bestowed with value only through imagination. Someone had made it and painted its surface. It once decorated another's world. Resting on a shelf in my painting studio, it reminds me how a communal spirit, past and present, gives heart to each new creative act. Taking my turn now to work the soil and mother my child here, I am sustained by the garden's history, real and imagined.

An artist is always excavating. On days when I feel like exploring, I dig through my pile of art books or make a trip to the library. There I discover an artist unknown to me or find a new perspective on an artist I thought I knew well. I make expeditions into the city to museums and galleries, where I can touch the paint with my eyes and hear the painter's message more clearly. A friend asked if I did this to get new ideas. It is not that; ideas are plentiful. Rather, it is to be among like-minded souls, to speak with others in the language of paint, and to gain insight into the creative process. Knowing who has gone before and what other artists in the greater community of artists are doing strengthens my resolve. If ever I doubt my persistence in seeking this painting course, other artists speak to me from the books and gallery walls. There is no substitute for doing, they say. Keep going. We are all uncovering what we seek.

After digging the bed down two feet, I prepared the soil, sifting out rocks from the old dirt and mixing in mushroom compost. The bed has been planted and growing for a year and a half, but it is sinking. I need to remove the plants, work the top layer, add more soil, and replant. What will my legacy be to this little bed—a lost paintbrush, plastic plant-identifying markers, black tubing and drip emitters, the arms and legs of my son's broken superheroes? When a future gardener digs in this bed, she may discover traces of an artist and mother who grew a garden. I wonder if she will find, as I have, a prize of immeasurable value in the dirt.

A communal spirit, past and present, gives heart to each new creative act.
Keep going, it tells us. We are all uncovering what we seek.

Three

PLANTING
THE
SEED

To make a prairie it takes
 a clover and one bee,—
One clover, and a bee,
And revery.
The revery alone will do
If bees are few.

EMILY DICKINSON

MYSTERY SEEDS

My son's horticulture training began at a tender young age. We planted our first seeds together in our little urban garden the spring he turned two. The radishes were the most satisfying because they grew the quickest. The carrots were the most delicious, although none of them grew to full size because we pulled them up one by one to check their growth and ate them all. Our pumpkin plants were the most astonishing. One monster plant threatened to overrun our tiny yard, but we let it grow to full size and measured its vines to see if we could get a world record.

Each year of Quinn's preschool, he had planted seeds in milk carton pots and brought home the delicate plants for Mother's Day. When Quinn and his five-year-old buddies were ready for bigger challenges, I volunteered to help his kindergarten class with their garden. Designing the project to tantalize their natural curiosity, I called it "Mystery Seeds." My plan was to help them plant the seeds in the classroom, watch them sprout, identify them, and then transplant them into the garden. As it turned out, for the most part the mystery seeds remained mysterious.

I bought packs of unidentified flower mixes at the nursery, then called the seed packager to find out what seeds were included. The customer service representative couldn't answer my questions. Apparently, all their leftovers were thrown into the mix. The only clues were the pictures of flowers blooming on the front

of the packages, but even that, she admitted, couldn't prove the contents. I decided to continue with the project, not knowing how it might turn out. I bought black plastic seed-starter trays and filled them with potting soil. In the classroom, I spread the seeds from the packages onto cookie sheets so that the children could see the variety of seeds and could each pick a few to plant. The seeds ranged from nearly microscopic dark specks to flecks that looked like bits of hay to small beige pea-shaped kernels to a few large black-and-white sunflower seeds. It is never short of amazing that such a tiny, inconsequential speck of nature can grow into a big, beautifully articulated flower. It renews one's faith in all possibilities.

In the classroom, the children came to me in small groups ready to start planting. They poked holes into the dirt with their fingers, then carefully selected their seeds. Fighting naturally occurred over the biggest seeds, and the sunflower seeds disappeared first. The kindergartners planted their seeds in the holes, covered them with dirt, and watered them. Then we waited. Each day a child would take the job of misting the planting boxes with water. We waited some more. One by one, the mystery seeds sprouted, soft leaves unfolded, delicate tendrils unfurled. Sweet peas and nasturtiums took the lead in the race for the longest sprout, their vines trailing over the edges of the planting trays. Each child wanted his or her plants to grow the fastest, to be the biggest. Some children were disappointed. Their seeds didn't grow. This happens in life, too, I thought. That's why it's important to plant many seeds. I didn't dwell on this lesson, and neither did the children. During spring vacation the seed tray dried out. We never did plant the mystery seeds in the garden.

In all matters of creativity, little ideas and big ideas sometimes produce results, but sometimes don't. We hope our efforts will grow and we do our best to make it happen. We may water and nourish, give light and air, but we really can't compel something to thrive. The life force of the seeds and ideas generates growth, sometimes because of, often in spite of our worthiest efforts. Looking back, we can sometimes pinpoint the moment or the event that was the seed for something wonderful—a painting,

a song, a new friendship or business venture. At other times, we throw out a handful of seeds that grow and flower, reseed and produce a garden in which new opportunities flourish.

A dozen years ago, my husband and I had a simple idea to write songs for children that they would enjoy along with their parents. We wrote a collection of spirited songs with positive messages and made audiocassettes. We gave most of them away. But people asked to buy more and our children's music business was born. It developed into a series of audiotapes, a video, book publishing, and a licensing program. More than a business, our children's music has introduced us to wonderful people and experiences that continue to make our lives more colorful and meaningful.

We've also learned that some things don't work out as anticipated, regardless of best-laid plans and ironclad contracts. There are no real guarantees other than the agreements we make with ourselves to keep trying. The task of sowing our creative seeds is ongoing, never-ending. It requires of us giant leaps of faith. If a black speck can grow into a flower, surely something will sprout eventually from an idea deposited in our fertile soil. Whatever happens, we have more seeds to plant.

Although we can't compel something to thrive, we can keep planting seeds. There are no real guarantees other than the agreements we make with ourselves to keep trying.

SPRING PLANTING

S pring arrived with a promise to help plant the garden at Quinn's school. There is a perk for the child whose mom volunteers: he gets to be in the first group. Quinn joined me, then picked four of his buddies for the planting jobs. We trooped out to the garden, spades in hand. A sunny stretch of dirt between the neighboring apartment building and the school's playground, the garden was divided into four-by-eight-foot sections—one for each class. In Quinn's classroom's plot rested the gnarled remains of last fall's pumpkin plant, a few weeds, and dirt still damp from the morning dew.

Few things I've witnessed match the sheer joy and fresh, raw energy of five young boys on a sunny day set loose in a garden to dig in the dirt. They attacked the earth with their spades, flinging dirt, making holes big enough to plant footballs, not tiny carrot seeds. Their greediness astonished and delighted me. Each boy wanted the most, more, lots, first. The natural instinct that is so charming at five can, of course, be a sign of deviance later in life and our society discourages it, but asking for more and conforming less is necessary for creative work. Some of our most talented and productive citizens have carried their youthful energy with them into adult life to amaze and benefit us all. My five gardeners worked intently until their shift was done. The casual observer might have thought they were just playing

wildly, but the shouts and laughter and flying dirt betrayed their serious work.

I left the school that day wanting to attack my painting in the same way the boys had attacked the garden—with absolute intent, belief, desire, hunger—demanding all from it, connecting to it directly with my body. At home in my studio, I went to work on a canvas with a garden scene in progress. My hands flew across the canvas, painting and wiping the paint, stroking away the image that had been there. Five spades appeared. The paint became the dirt. I played with it, slapped it on, dug at it. I finished the painting in a short time and named it "Spring Planting."

On several afternoons that spring, I returned from working with Quinn's class and made paintings inspired by our gardening and art sessions together. When the children painted clay pots and bamboo poles, I observed how their painting techniques—exuberant, cautious, conforming to shape and line, or splattered and smeared with abandon— showed the stamp of their personalities, already strongly formed. I encouraged the splatterers and smearers, knowing that their days were numbered: so much in our formal education rewards conformity and punishes abandonment to passion.

An artist may spend her whole adult life trying to return to a way of working that comes naturally to a five-year-old. Of all the disciplines, perhaps contemporary dance allows the most direct route to that body knowledge. Viewing dance gives us the sense of freedom we get from seeing children at play. Dancing, our bodies remember. Whenever I work with children, I scoop up their energy and take it with me into the painting studio. With the child as my teacher, I move freely, am less critical, and have more fun.

Artists may spend their whole adult lives trying to return to a way
of working that comes naturally to a five-year-old.
With the child as our teacher, we move freely,
are less critical, and have more fun.

Catalogs and Confusion

I was born in Missouri, the "Show Me" state. Maybe this is why I have trouble with catalogs. Whether selecting art supplies or plants, I'm reluctant to make choices based on slick, printed pages. I need to feather the paintbrushes across my palm and assess the grain of the canvas with my fingertips. No matter how stunning the gardening catalogs that fill my mailbox each spring, I can't commit to a plant whose colors I've seen only in ink.

In most things, my choices are guided by knowledge acquired through the senses and the hard knocks of trial and error. The printed page can only prepare me up to a point. Yet choosing what to put into the garden is a relatively low-risk decision compared to important decisions one makes in work and life. I confront my resistance to catalogs, examining the advantages and disadvantages of my learn-by-doing methods, and consider trying another approach. Today's mail offers a chance to experiment. I sit down with a new gardening catalog, determined to place an order for spring planting, but I'm soon confused and exhausted by all the options. Sensory experience, which serves as my interpreter and guide, is missing from the pages.

As I close the catalog, I realize there is a joy in choosing that is absent in ordering from a book. I like to see the plant blooming, sniff its fragrance, and imagine its volume filling space in my garden. My decision-making process is a blend of intuition, knowledge, and chance. In painting and planting, the little choices I make add up to a sum that is often surprising. Trying out the unknown

usually requires me to confront failure before I learn to incorporate the new into my methods. This has positive benefits. Too many easily selected options, however, confuse one's intent. In work and in life, I want to make decisions with all my senses engaged.

It would be great to dial an 800 number and stay out of the traffic. But before long, I'm on the road again, dropping into the art store to test the resilience of a watercolor brush, then stopping at the nursery to smell what's in bloom.

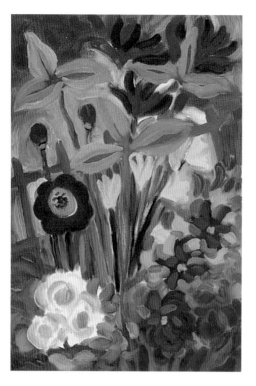 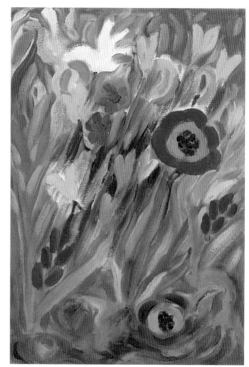

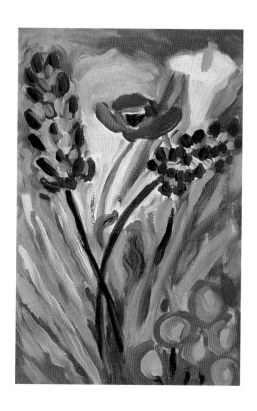

The little choices we make add up to who we are. There is a joy in choosing with all the senses engaged.

ESTABLISHING ROOTS

The trees, after a sharp wind,
 are no longer luxuriant,
But the pine still casts a full shadow.
It has found a place to rest;
For a thousand years,
 it will not give up this place.

T'AO CH'IEN

DARK AND QUIET DOWN THERE

A feisty rosebush in my urban garden had been planted on the north side of a fence, ensuring a shady future. Sporting powdery mildew, rust, and black spot, the plant was a case study in diseases. As soon as the pink roses bloomed, they began to turn copper around the edges of the petals. From a painter's point of view, it was beautiful; but it could break a gardener's heart. Ideally, the bush should have been moved, but there was no other spot for it, as the dirt was thickly veined with the roots of the old pine tree. On frequent walks to the grocery a few blocks down the hill, I'd pass my neighbors' tiny but lavishly planted front yards with their well-tended roses. I became intoxicated by their fragrance and began hovering around rosebushes at the nursery.

When we moved to the country, I went rose crazy. I bought several bushes that I kept potted the first year to easily transport them in and out of the studio. I tried painting them in many ways, was not satisfied, then painted over the canvases. While I was burying images of beautiful roses in paintings, my longing for a rose garden resurfaced.

I chose a sunny strip of ground to the west of the house next to the boysenberry vines. I worked the soil, amended it, and with Dennis's help, shored up the new bed with railroad ties. Counting my studio models and three bushes given to me as gifts, I had eight plants. The roses had done well in the pots; I couldn't wait to see how they would

flourish in the ground. I dug holes, nested the plants into gopher-resistant wire baskets, laid down weed cloth, mulched, fertilized, watered, and waited. Not only did they fail to bloom, they looked pitiful. Their spindly stems drooped. I whined to Sarah, a professional gardener. "Don't worry," she said. "They're just putting energy into their roots."

That advice immediately made sense of the roses' problems as well as some other pressing issues. I was trying to prepare for my first solo museum exhibition. The museum had selected my work based on the urban garden paintings, but since uprooting my studio and moving it to the country, my painting had changed and was still in transition. I wanted to include recent work with the earlier paintings, but I was struggling with the new paintings. Also, as much as I loved our home and the country environment, the move had taken a greater emotional toll than I realized. I was feeling isolated. I had pulled myself away from my design business, friends, and city activities which had structured my life for many years. In addition, our children's music business was in trouble. The company responsible for marketing our tapes had revised its corporate strategy, leaving children's music out but not releasing us to make other plans. Everything had looked rosy before our move. Now the promises were dying on the vine.

For several weeks, I observed the roses. Like them,

I was establishing the taproot of my intentions, hoping to find a firm footing once again. So much in nature and in art is a mystery. I trusted that in a dark, quiet place below the surface, something powerful was taking hold. I ignored the roses. In the studio, I thought only of making gifts to myself, enriching my life with the paint, and not worrying about the results. As the time for the exhibition approached, I found a way to make the paintings from the two distinctly different gardens work together. In all the preparations for the exhibition, the isolation dissolved. New business opportunities knocked, offering promising directions for our children's songs. And in the rose bed, the first buds opened.

In a dark, quiet place, we establish the taproot of our
intentions, hoping to secure firm footing.

UNTANGLING

Weeds of every variety take over a new bed in a wink. The creeping oxalis's shallow roots pull out easily. More ambitious weeds have grabbed on to the bordering path, wrapping their roots around the gravel. I pull them, yanking up pebbles and dirt in baseball-sized clusters, loosen the roots' grip, and shake the gravel back onto the path.

I divide a bushy clump of lamb's ears taken from another bed. Threading my fingers through the tangled roots, I marvel how the cluster of lamb's ears is held together by these underground supports, not by a strong stem. Disengaged, the velvety ears fall apart and lose their orientation. When replanting, I tuck the roots gently into the soil, positioning the ear-shaped leaves carefully above the ground.

The rooting of creative work follows nature's way. Part of the creative process is learning to move beyond entanglements for new ideas to take hold and nourish the work. Just as a plant cleverly finds a way to root in, the artist invents new systems and improves on established ones.

Lately, I've been considering the potential of my entanglements. At times, in my life and work, I've felt like the tenacious old pine in our urban garden, tapped into its secure place in the sun, weaving its roots past concrete barriers. I've also been like the weeds, clinging comically to false footholds that give way with

little provocation. Today, I feel like the freshly transplanted lamb's ears with my roots disturbed, not sure which end is up. The only thing to do is work my tender tips into the soil and hope to guide them well as they push into unfamiliar ground.

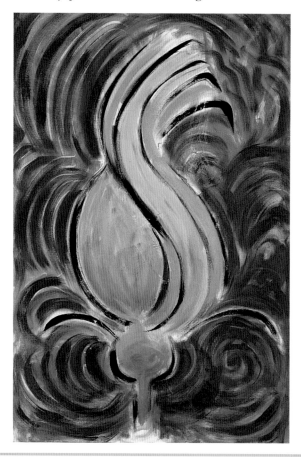

Part of the creative process is moving beyond entanglements for new ideas to take hold and nourish the work.

GOPHER PARTIES

Gardens calm the mind and reassure the soul that the world is a beautiful, bountiful place. Fully at peace, we sit quietly and survey the generosity of nature, the results of our labors, and the season's graces. Then the earth moves. Slowly at first, then more rapidly, the ground erupts. There is an enemy among us. It's the gopher.

These small, furry creatures who live in our gardens' basement bring out our most aggressive instincts. Those of us who always thought we were pacifists find ourselves wondering, "Should I use the cyanide capsules now or just drown the pests by filling their holes with water?" So far I haven't been able to bring myself to commit the act. Consequently, fresh mounds of earth appear daily in the garden, toppling over small plants and burying flowers. I put plants into the ground in baskets formed of aviary wire because, as garden lore assures, gophers cannot work their way through the wire mesh to eat the roots of tender young plants. Given the chance, they would devour a smorgasbord of annuals and perennials. Eating their way up from below ground, they inhale a stem for the main course, then while we watch, suck down the flower for dessert. They play with bulbs, roll them through their underground tunnels and leave them to pop up here and there in the garden—gopher surprises!

As soon a you dig a new bed, water it, and get the plants growing, the gophers arrive. They relish freshly dug, moist soil full of tasty new plant roots. Underground, they are having a gopher party, getting drunk on rose-root beer. The neighborhood dogs join

the fun. Reenacting scenes from one of our favorite Dr. Seuss books in our own backyard, the gophers tunnel up from below while the dogs dig down from above: "Go, Dog, Go!" Dirt flies, plants keel over, flowers succumb to battle fatigue. Spent from their frenetic play, the dogs collapse in the shade to nap. Who knows where the gophers go.

I assess the damage as I do a seven-year-old boy's room after a sleep-over. I push dirt back into holes, smooth down the mounds, set up toppled plants, wash off blossoms. To survive as an artist with responsibilities to a home and child, it is better not to get too attached to neatness and order in the garden, the house, or the studio. Years ago, Dennis and I lowered our housekeeping expectations. While the house stays messy for days and laundry piles up, paint finds its way to canvas and music gets made.

Although my natural inclination leans toward order in all areas of my life, I have discovered that as a painter it's best not to clean up the messes too soon—they may trigger spontaneous shifts that feed the artmaking process. When I anticipate a result before it appears, if the connections are too clean and direct, I may miss something wonderful happening before my eyes. If I kill the gophers, I'll miss the dog and gopher party.

Every now and then I succumb to an uncontrollable desire to attack the chaos and embark on a furious cleaning of my son's room, the studio, and the garden shed. When finished, I sigh in

satisfaction. All the little plastic figures and Legos lie sorted by size and suit in their bins in the playroom. Footprints and spilled juice disappear into the sponge mop. Canvases line up, paper sits in stacks, and brushes stand freshly washed, waiting patiently for wet paint. Tools hang neatly on their hooks in the shed and the garden sports a crisp haircut and grooming. I feel fortified; I'm in control.

Then the gophers strike. I reconsider the cyanide capsules, hesitate, and take the humane route, flattening the erupted earth with my boot. I'm learning to coexist with the enemy. After all, what happens out there in the patch of earth, like what happens in a painting or in life, has to be somewhat left to chance, the forces of the elements, and an occasional foe who messes it all up.

What happens out there in the patch of earth, like what happens in painting or in life, has to be somewhat left up to chance, the forces of the elements, and an occasional foe, who messes it all up.

The roses. Wanting something more from them—still thinking of large gardens—landscapes beyond the wall—abandoned gardens. Suggestion of growth—real to abstract. Thing coming into being, into focus. Other things just suggested. Feel like a line—however thin—connecting me to something. Something in me to be pulled out—something deep connecting to the open, expansive— full of color, light, joy.

TENDING TO

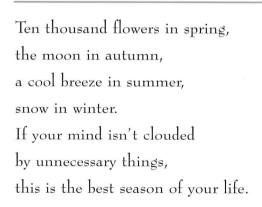

Ten thousand flowers in spring,

the moon in autumn,

a cool breeze in summer,

snow in winter.

If your mind isn't clouded

by unnecessary things,

this is the best season of your life.

WU-MEN

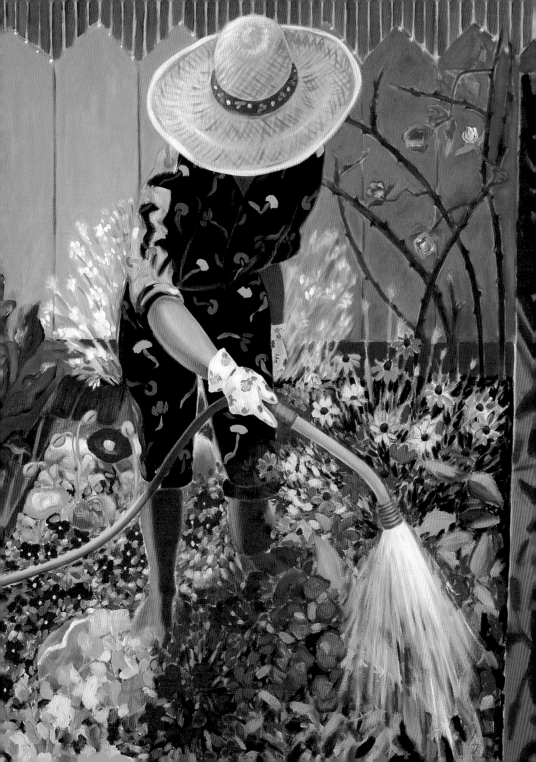

Paying Attention

Entering the garden, I breathe in a jasmine elixer that affects my senses. At once aware of the expansive blue sky and the buzzing of a bee, I feel like Alice in her Wonderland, ready to shrink or expand to explore this garden world. Crouching down to pull weeds in a flower bed, I'm annoyed by a fly. It tickles my leg, then lands on the *Helichrysum* "Limelight." From the fly's perspective, I admire the velvety softness of the yellowish green leaves. While the fly is still knee-deep in the leaf's carpet, an ant crawls across my peripheral vision, making its way over the surface of a flat rock beside my foot. The stone had looked smooth to me, but upon closer examination, I see how its pocked surface challenges the determined ant with a rugged terrain of hills and valleys.

Standing to stretch my legs, I immediately enlarge and refocus on the bigger picture. The garden's colorful patterns unfold around me like a quilt. The details blur; everything appears soft. Many hands have stitched this patchwork together. I'm adding my bits and pieces over time. Here and there a few things detract from the harmony of the design. I make a mental note to attend to them. A bird chirps; I look up. The blue spruce and acacia trees tower over me. I am enveloped by the garden's green and the sky's blue. A blackbird soars high above. Now I'm small again.

Looking down, I am reattracted to my weeding task and begin pulling, my fingers seeking to distinguish the roots of the weeds from those of the flowers. My hands are learning to discriminate as much as my eye. As a painter, I'm used to relying on visual infor-

mation to guide me. In the garden, all my senses receive messages that teach me how to be a gardener.

Weeding out helps me to see clearly what is there in the flower bed. The weeds were filling up the background, confusing the whole scene. When they are gone, the burnt umber–toned earth sets the plants apart from one another, framing the distinctive beauty of each flower. I can use this lesson in the studio. I'm having difficulty with a painting; it contains too much. The painting's voice is muffled in a chorus of shapes and colors. Painting, as so many other things, is as much about what one takes out as what one leaves in. I try to see my paintings in progress

from different perspectives: up close and personal, distanced and analytical, reflected in the mirror placed on the back wall of the studio, or scrutinized at arm's length. I keep Polaroids of a painting's evolution. The small format makes it easy to see at a glance how a group of paintings is developing. There are a few paintings I begin to make again and again, and just as often paint out. To paint them, I must see clearly with my mind's eye and use all my senses for the images to emerge, or I lose them.

As it takes a lifetime to mother a child, it may take that stretch of time to learn to grow a garden or paint in one's true voice. The manifestations of one's nurturing, ideas, values, and small tasks are not finite products, but rather a series of revelations. Participating attentively in their creation gives one back realms to explore. The child becomes a friend whose personality intrigues. The garden grows lush and dies back, continually offering up its bare spots for further experiments in cultivation. The paintings point to other places to go. Shrinking to follow the brush tip or expanding to view horizons of color, I participate fully in this journey, paying for the privilege with all my attention.

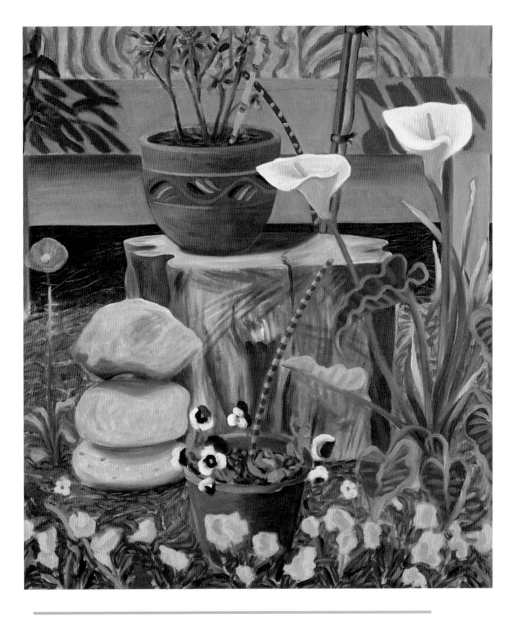

The manifestations of our nurturing, ideas, values, and small tasks are not finite products, but rather a series of revelations. Participating attentively in their creation gives us back realms to explore.

DRIPS, DROUGHTS, DELUGES

O nce my sister Carol and I danced down the streets of Disneyland singing in the rain. Miming Gene Kelly, we skipped and twirled across the pavement. Blue dye from our plaid madras dresses ran down our legs and stained our white canvas tennis shoes. With every step, water squished out of our shoes, adding a percussive element to our performance. As I recall, our parents watched from a dry spot under an awning. Other passersby looked amused or disapproving. Carol and I didn't care; we were abundantly happy then.

Rain doesn't usually affect me in such a lighthearted way. More often, dark skies and raindrops depress my spirits. But since I've been gardening, I can cheer myself with the thought that the rain is good for the plants and for the water table. Our well is deep, though not impervious to drought. During the rainy winter months, we use water freely. But toward the end of the hot, dry summer we mind the tap. A drip irrigation system ministers to the garden's thirst. How this black plastic arterial lifeline works is still something of a mystery to me.

The heart of the system is our well pump, delivering twelve gallons of water per minute. The fine science of the drip system is to marry the right emitters in terms of gallons per hour to the specific plants being watered. If you demand from the well more gallons than it can give, the system doesn't function properly and the plants suffer. The drip system is designed to serve several sections of the garden at any given time. As plants are

added, grow, or are removed, the system must be adjusted accordingly—more or fewer tubes and emitters, or different rate emitters. To complicate matters, our soil is sandy and the water has a high mineral content, so the emitters get clogged constantly. Just because the system is turned on, it doesn't mean that every plant is getting its allotment of water. And occasionally, when a pipe breaks or an emitter comes loose, a plant's thirst is more than quenched. It develops root rot before the leak is noticed.

"Notice" is the key word. With just the right amount of water, plants flourish. Too little causes wilting; too much, drowning. Paintings are a bit like plants in this regard. I adjust the flow of my attention accordingly. Sometimes a painting requires drops of consideration over a long period. The image comes into being and changes slowly, responding to a light touch. Sometimes I need to pour on the attention, applying paint to the point of excess. If I feel it's ruined or not finished, but I don't know what to do next, I turn it to the wall. Depriving it of my scrutiny and brush completely, I ignore it for weeks or months. Then I see if it can be revived or if it has succumbed to the drought.

The garden's water wisdom is teaching me to find the balance in giving and receiving. Our first winter in Sonoma County was the wettest in twenty years. Everywhere, trees lost their footing in the soggy ground. The river to the north

swelled. Day after day of rain turned trickles into torrents that cut deeply through roads, lifted bridges, and flooded homes. Then the waters receded. The mud was cleaned up. Repairs were made. Households were reestablished. Summer came, hot and dry. We began minding the tap.

Too much or not enough, how difficult it is to get it just right. In the creative work cycle, the artist must be aware of how much she has to give and how much the work can receive and give back. If she's depleted, the work droops temporarily, as does the artist. She consoles herself, knowing that most painters have suffered through dry spells. If she's overflowing, the work may become saturated. The runoff evaporates and pours down again. Abandoning herself to passion and armed with buckets, she goes dancing and singing in the rain.

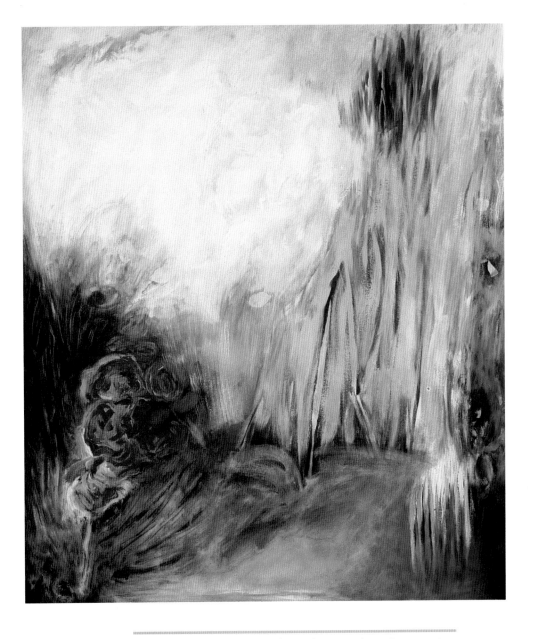

In the creative cycle, we learn how much we have to give
and how much the work can receive—and to adjust
the flow of our attention accordingly.

This painting "Nest" reminds me of so much—
I have been trying to paint this for years.
Just keep at it—the tenacity I know I have
will liberate this thing in me. Attack it. Love it.
Dance with it. Painting is like dancing in that
you work and work in order to achieve effortlessness.
The final surface must not look labored, but
as if it all happened with a touch, a lift, an impulse.
The dancer trains. The painter trains. The painter's
performance—over time—culminates in the painting.
Every stroke, every nuance—as in the gestures and
postures, muscles and releases of the dancer—work
together to create a piling on of moments that
encapsulate memory and desire.

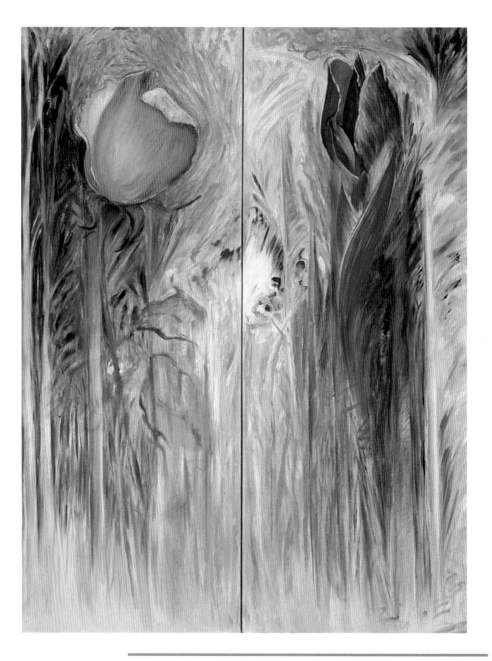

Creative expression beckons with the tool that engages our desires so much that we want to pick it up and use it.

TOOLS OF THE TRADE

O n Christmas morning, I received a present of a dozen new paintbrushes from my brother's girlfriend, Liz. As my family opened their packages around me, I contentedly held the brushes in my hand. I needed no other gift. Due to a number of circumstances, I hadn't been in the studio for nearly two weeks and when the morning began, I was out of sorts. The more I've painted over the years, the more difficult it is to have a number of days pass when I don't put brush to canvas. The feel of the satiny smooth wooden handles instantly connected me to the practice of painting and I felt my body shift into a relaxed and alert posture. My senses opened up. This, I realized, was how I felt when painting—calm and excited at the same time. Like the ringing bell that caused Pavlov's dog to salivate, the brushes whetted my painting appetite.

Poised to paint, I viewed the Christmas scene anew. Wrapping paper decorated the floor. The sun bounced into the room, reflected off the glass ornaments, and lit the familiar faces around me. Knowing that I wouldn't make it into the studio once again that day didn't matter. Holding the brushes firmly, I sank into the festivities of the morning. A few days later, back in the studio, I put my other art tools to the test. Pencils came in a close second, but nothing held the power of the brush. I think about the role tools have played and are still playing in human evolution. Do people choose their professions by an affinity for the tools of the trade, or do the tools choose them?

When I began gardening, I entered a new world of tools: spades, hoes, rakes, shovels, pruning clippers, shears, loppers, electric trimmers, wheelbarrows, pitchforks, and buckets. An acquisition period began. I browsed in hardware stores, nurseries, and discount depots touching cool metal and gripping varnished wood in my hand. I listened to the hardware salesman expounding on the virtues of certain hoes and weed whackers, priced his suggestions, then bought the cheaper models. The hoe has served me well. The weed whacker rusted in the garden shed.

Several times, I've made bad investments buying inexpensive clippers. I handed over my credit card for a good gas-powered mower and weed whacker, settled for manual hedge shears and later regretted it. When my brother, Lloyd, visited, I eagerly accepted his gift of an electric trimmer and his offer to groom the ragged hedges.

The power tools get used occasionally, out of necessity, with resignation bordering on fear of major bodily injury. It's the red plastic bucket holding my spade, fork, and clippers that I reach for whenever I head out to the garden. I love the feel of the small garden tools in my hand while I dig a fist-sized hole or snip an extraneous stem. I also like the heft of the wheelbarrow and the weight of the shovel, its slice of metal edge against the sole of my shoe.

Humans respond to tools in their hands. Tools entice the creator to work with the body and mind in synchronicity. Finding the tool that suits one's personality and creative inclinations allows one to produce and enjoy the process. In this age of information, we all use communication tools every day. But I don't get the same thrill from cradling a plastic phone receiver or manipulating a mouse that I do from balancing a paintbrush between my fingers. Whatever creative expression beckons, we must find the tool that engages our desires so much that we want to pick it up and use it. Spades and shovels call out to gardeners, inviting them into a creative process through tools. Pens, cameras, brushes, chisels, flutes, and bows call out to others. I have an image of myself moving into the twenty-first century. In the background, I hear a computer humming, a mower churning, a car engine running, and a phone ringing. But I quietly greet the new millennium, unplugged, with a brush in my right hand, a spade in my left, and a pencil gripped lightly between my teeth.

TAKING TIME

Birds make great sky-circles
of their freedom.
How do they learn it?
They fall, and falling,
they're given wings.

RUMI

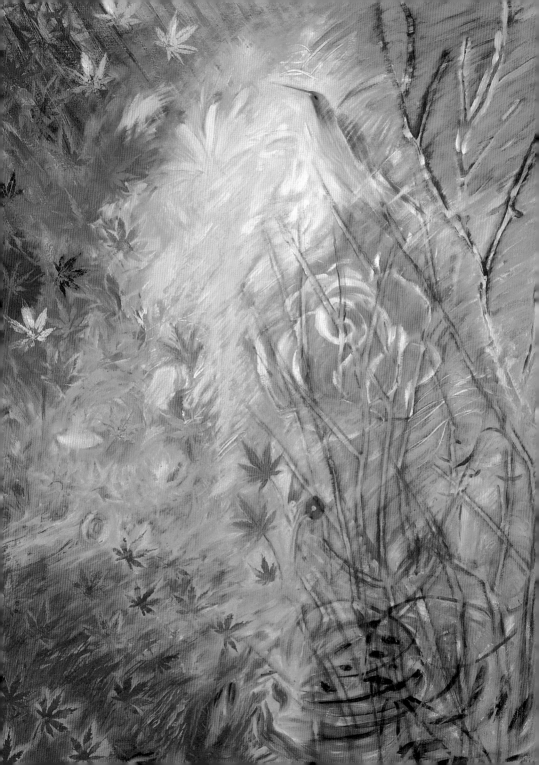

PUTTERING

Gardening teaches the fine art of puttering. Looking through the kitchen window, I see that the wind has knocked several oranges off the tree. It would be a good idea to pick them up now before the rain starts again. I'm waiting for a phone call, but this will only take a minute. I grab the collecting pail from the sink counter and notice the compost bucket is full, then head out to the garden to quickly dump and gather. After emptying the bucket, I pass by the pond, where I stop to scoop out some duckweed and retrace my steps to the compost bin. Moving toward the orange trees, I'm delighted to see the peas in the vegetable bed are blossoming—a striking fuchsia and deep purple. They have grown tall overnight, and with them the weeds. The raised bed is tented with bird netting supported by bamboo poles at the periphery and in the center. I caged the garden to keep the birds away from the young lettuces, thinking I would pull the netting down when the plants were established. But I like the feeling of this outdoor room with its see-through walls, so it has become part of the garden's architecture. To enter, I loosen the net where it is hooked onto the boards that frame the bed. Inside the net tent, I pull a few weeds from among the peas and check to see that the vines are securely attaching to the net. The lettuces need weeding, too, and when that task is done I tear off some leaves to take inside for lunch, finally stopping to fill my pail with oranges. A half hour has passed and still no phone call.

Puttering has its virtues in the studio, too. Although it could be called dillydallying, procrastination, or avoidance, puttering is part

of a ritual warm-up. It allows the putterer to sneak up on the work and find a point of entry. I walk into the studio and confront the paintings in progress. There are some problems I'm not sure how to solve; I don't really know where to start. After a few moments of contemplation, I want to begin painting, but the trash needs emptying. On the way to the garbage can, I pass my worktable where a gesso brush left soaking overnight demands my attention. I go to the house to wash it because there is no sink in the studio. There I spy the plastic containers and tuna cans I've been saving for mixing paint stacked near the kitchen door, carry them back to the studio, and begin uncapping my paint tubes.

Turning to nature to inspire my palette, I roam the garden to see what's blooming and return to the studio loaded with an array of colorful blossoms, a variety of mottled leaves, sticks, bark, and pebbles. I carefully study the colorations of blue lobelia, salmon alstroemeria, silver-toned dusty miller, and a cinnamon-hued leaf. As I mix paint to approximate nature's palette, the colors excite me. Now I'm ready to work. I pick up the brush, entering the painting with a new color that enlivens the canvas. Puttering has once again served as a kind of glue for the creative process. I hear the phone ringing in the distance. Whoever it is will have to leave a message.

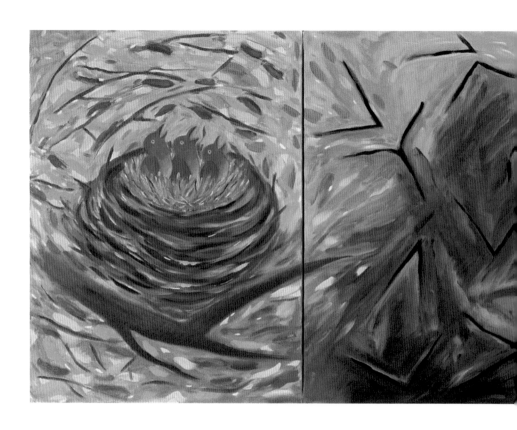

Puttering is part of the ritual warm-up for the creative process.
It allows the putterer to sneak up on the work.

Slappy the Goldfish

A charming feature of our country garden is an octagonal cement pond measuring about eight feet across. From the center rises a cement basin with an unadorned brass tube. The fountain spouts when we turn on the faucet hidden under foliage in the surrounding bed. The moment I first saw the pond, I envisioned a mini-Giverny complete with Monet's lilies and bright koi flashing in the sun, although at the time there was nothing in it but duckweed and hundreds of mosquito fish.

As soon as we moved in, the pond drew Quinn and his new neighbor friends like a magnet. They hammered together scrap wood, sailed their boats, and sank them with pebbles. Turning on the fountain to its full force, they ran under the fifteen-foot-high arc of water that splashes onto the path looping around the pond, cooling off their hot bodies on a summer afternoon. They floated and drowned their toy action figures, sinking them with fallen oranges. Water lilies are too precious to be subjected to such behavior and childhood too short to spoil such fun, so for the first season, I let the pond be.

A Japanese maple tree stands gracefully by the pond's edge. I placed a wrought-iron bench nearby so I could sit and paint the reflected sunlight, sky, and foliage. Once the kids were back in school, the pond became my spot for contemplation. I learned to sit and just watch the clouds drift by mirrored in the shifting colors of the

water. This was an entirely new experience for me. I had always equated being virtuous with staying busy. The pond is teaching me how to be still.

One chilly spring day I decided to muck out the pond, having no idea what a job it would entail. It took three days. Quinn and I caught the fish in a net and placed them in buckets of pond water. I siphoned the murky water through a hose and let it drain out around the base of an orange tree. The bottom of the pond was layered with several inches of black goop, decayed maple leaves, and flopping silvery fish that

had been too clever for the net. Wearing my rubber boots, I shoveled the muck into buckets that I dragged across the yard to fertilize the boysenberry vines. My berry crop was excellent that year. I scraped the cement bottom clean, filled the pond, and put the fish back in their home. A few days later, the water level was down. Apparently, the sludge had acted as a filler for cracks in the concrete. I now had a clean but leaky pond.

At the Apple Fair in town the following fall, we bought Slappy the Goldfish. He is many times larger than the mosquito fish, and thus an easy target. Amazingly, he's eluded the neighbor cats, raccoons, and sunken boats. Concerned about Slappy's well-being, I've asked the children not to throw things into the pond. I've added an umbrella plant, cattails, a water iris, and a small lily. The pond is a world unto itself. Through all seasons, I sit by it to meditate or draw, or I visit it for inspiration. The quiet moments spent there instill in me a calm center from which the ripples of the creative process can emanate.

I watch for Slappy's bright flash of orange. He hovers near the surface, hiding under the duckweed. When I reach in to pet him, he lets me touch him briefly, then scoots away. This summer we'll bring him a few friends his own size. On the occasional quiet summer afternoon, I'll sit nearby as they swim freely and the blue jays bathe, their splashes punctuating the pond's silent space in time.

Take time to be still.

ANNA'S HUMMINGBIRD

This morning a hummingbird hovered in the orchard. He sang, then flew straight up as high as I could see until he was a dot in the sky above me. Making a loud high-pitched shriek, he dove straight down toward my head, then swooped up just before impact and perched on a nearby branch. My heart raced. Our bird guidebook identified the rascal as an Anna's hummingbird—a male. He fit the description; he had an iridescent flaring, magenta-colored throat. I assumed he was defending his territory, but the book said dive-bombing was part of the male's display to attract a female. Noting my paint-splattered T-shirt, baggy sweatpants, and tousled hair, I wondered . . . couldn't he do better?

I took the moment back with me to the studio, where I pulled out a large primed canvas and put it up on the easel. My first strokes were strong and sure—a loop up into the air, a curve down. I painted the sky with a suggestion of clouds. I put sticks up to the canvas and painted lightly over them, leaving suggestions of branches. A thin layer of paint was enough—no overpainting, no laboring or reconsidering my idea. As I stepped back and decided it was done, Dennis came into the studio to see if I wanted to stop for lunch. Luckily, the interruption kept me from fussing with the painting, correcting and adding—destroying the spontaneity.

In painting, as in many creative acts, it's not always clear how much is enough. I grew up believing that if you tried harder at anything, you would make it better. Now I don't believe that is the only way, nor often even a useful way to proceed. After years of applying

my skills and talents in many areas, I see the wisdom in occasionally not trying at all. Birds don't struggle to fly; plants don't attempt to grow; children don't try to play. Sometimes we don't appreciate that which comes most naturally to us, yet what we do easily may be our best work. The painting I made of the bird's path is the most effortless painting I've ever made. Whenever I see it I smile, remembering the moment. I look for my little friend from time to time in the orchard. Perhaps he's found another home or, undoubtedly, a more stylish girlfriend.

Sometimes we don't appreciate that which comes most naturally to us,
yet what we do easily may be our best work.

NESTING

Out of my studio window, I see a northern mockingbird land on top of the brush pile and disappear into the discarded branches and weeds. Foraging for nest-building material, she quickly flies out, carrying a twig back to her nest in a nearby tree. My own nesting instincts have taken hold again, as they did before Quinn was born. I have my family; now I want a home to own. This unassuming house surrounded by nature's abundance, enfolded into a small-town community, is where I want to spend the years of our son's childhood. I'm cupping a wish close to my heart that we will be able to stay here as homeowners. Our landlord wants to sell, but our financial situation is shaky. Thinking about leaving this studio and garden brings on despair. I try to concentrate on painting and push the threatening thoughts out of my head.

I'm building my paintings as if my survival depended on them. I raid the brush pile for sticks, bring an armful into the studio, and press a curved and forked branch up against the canvas. With a loaded brush, I paint over the stick and release it, leaving a trace of the graceful arc and awkward prongs against the image below. It feels right to do this; I want the presence of the garden in my paintings. As I stencil twigs and branches onto the canvas, I find a rhythm. The painting becomes a chant. A humming penetrates every pocket of the studio, enveloping me in a shell of light and color and form. Through the window I see a sparrow dart about and vanish into the brush pile, where she has probably built her nest. Like her, I seek solace in a sanctuary of my own making.

A nest can be any cozy place where we feel safe. I remember lying on the couch holding Quinn when he was a baby, his sleepy warmth rising and falling against my chest. Napping with him worked a spell on me; I felt as if I had been carried away to an enchanted place. My mind would race with countless things I needed to do, but I was unable to move. Although I knew I could disengage myself, put him in his crib, and have an uninterrupted hour to work, I lay still. I had never known such complete peace and joy. When he roused, his sweet breath stirred the air. Wide-eyed and rosy-cheeked, he stared at me for a moment before his face woke into a smile of recognition. Then he would wriggle and squirm, getting on with the job of being a baby.

Creating in my studio nest, there is a magic time. It is not when the hoped-for phone call comes, offering the exhibition or contract. Nor is it in the hustle and bustle of preparations and celebrations. While painting, there is an occasional cluster of moments when I'm deeply at peace, blissfully embracing the weight of the work, feeling a cadence as measured as the breathing of a sleeping child.

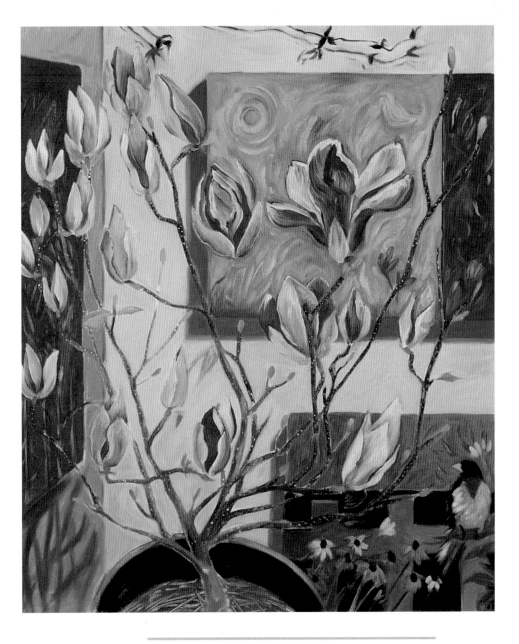

In creating, there is a magic time. We find solace
in sanctuaries of our own making.

PRUNING

I am shy of the gardener
called experience...

I am tangled and overgrown
uncertain of my center,
a wild rose running along the ground
blossoming into ever smaller
and briefer songs of the self.

PATTI TRIMBLE

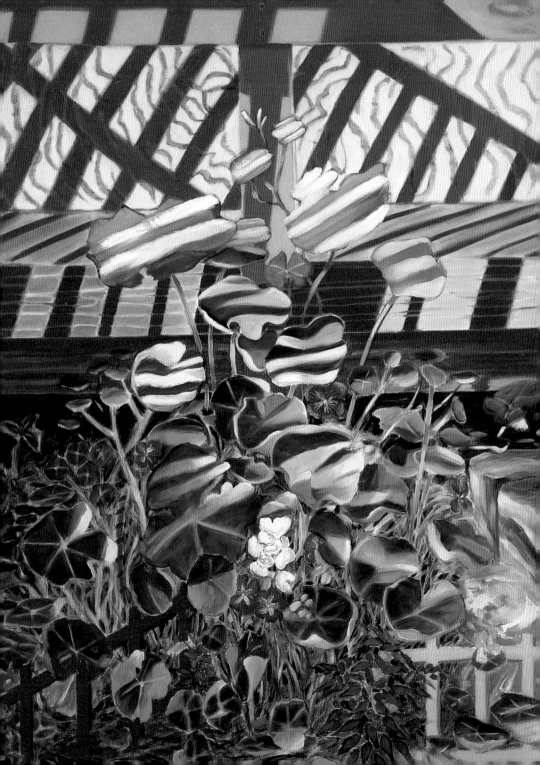

FEAR OF PRUNING

elé surprises me. She appears at my studio door, clippers in hand. I pick up my clippers on the table by the door and join her. I've been waiting for this day for several weeks; she has promised to teach me to prune the roses. Lelé and her partner, Sarah, took care of this garden before we moved in and they continue to give it a few hours a month of their tender touch and skillful shearing. Because of the winter rains and a rampant flu, they haven't been here since late November. Waiting for Lelé's lesson, I began to prune the roses on my own, making a few tentative cuts here and there, afraid to do my lovely bushes irreparable damage. I had cared for them, worried over their rust spots, and ultimately admired their prolific display of good health. Now the once-flourishing Trumpeter floribunda, which in July displayed over a hundred and fifty roses, makes the last offering of its long blooming season, a drooping red straggler hanging on for dear life. On this January day, I'm ready to get rid of the old, make way for the new. I need Lelé, the Rose Queen, to guide me through winter pruning; I still don't have the nerve to make the deep cuts.

Pruning is excellent therapy. It keeps plants strong and by association gives the gardener time to reflect, to conjure up a vision of what she hopes or desires to see in the future garden. Lelé begins with a few simple cuts. Anyone could have seen the wisdom in them. But soon she ventures beyond my comfort zone. I watch her and try to anticipate her next move. She examines the plant, cuts off a

few inches here, trims a wayward stem there, then moves in for the kill. Swiftly she cuts deep into the heart of the plant, taking a tall beautiful stem that has grown up in the middle of the bush. "It's better for the plant," she says simply. We're sitting on the damp ground, looking intently at a little bush. The plant must be reshaped like a funnel, keeping the center open. The cuts must be made above a lateral bud, angled forty-five degrees so that the plant is forced to follow the direction of the high point of the cut, the direction the near bud is heading. In this way the bush is shaped for beauty and free growth. Stems that cross over one another, however profusely they bloomed last season, lead to an unhealthy, unbalanced plant. Better to go for quality than quantity, I note— another truth laid bare in the garden.

In English accented with Spanish, Lelé asks about my husband, his music, and our music business. "It's like pruning," I acknowledge. She nods. We take the responsibility for the shaping, not just for what will bloom for the eye next season, but for the long life of the plant. There is no further explanation needed, but I think about it for several days. Lelé was a psychotherapist in her native Argentina. Which came first, her understanding of people or plants? In America she gardens, writes, makes monoprints in her garage, and sculpts cement basins for water gardens, using a teaspoon in her kitchen. I think about how much one must cut out of one's life to leave the country of one's birth, to leave family and

friends, and abandon a career. It's hard enough for me to throw away old letters and drawings. I think about risk and loss in painting. Artists live in their imaginations where the imagined becomes real. There are moments in painting when I feel utterly lost, breathless, and panicked when I take a beautiful image or passage of paint and destroy it, discarding strong directions and promising beginnings.

We are on our sixth bush out of eleven. I'm not even close to going it alone. Did I think I could learn deep pruning in an hour? "The rose is confused," Lelé says as she carefully moves one stem to get a good cutting angle on another. "Now," she asks, "what next?" I point at a wayward stem, growing from another respectable stem. She looks, then cuts at the base of the good stem. "It's better for a more healthy plant." We're near the end of the rosebush row. I'm starting to see what's needed. "You go ahead," invites Lelé. I point. She nods. I snip. Lelé says she usually talks to the plant. Today she is talking to me. It must not be as satisfying to her, but I'm happy to have her as my pruning mentor.

A few days later I bring into the studio a canvas that was finished months ago. It has been photographed and documented in my files as part of my body of work. It's a strong painting, but it has served its purpose. I put it on the easel and swiftly paint over it. The new image, on its way to becoming something else, surprises me. I am struck not so much by what appears in the fresh paint as by what I am now able to discard.

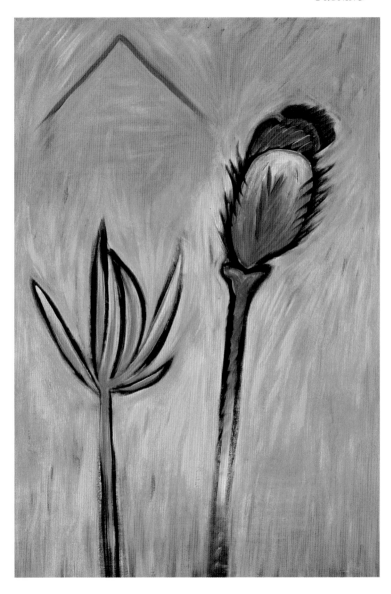

We have responsibility, not just for what will bloom for the eye
next season, but for shaping a vision for the future.

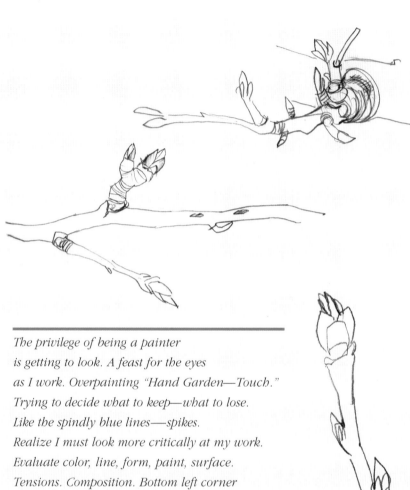

The privilege of being a painter
is getting to look. A feast for the eyes
as I work. Overpainting "Hand Garden—Touch."
Trying to decide what to keep—what to lose.
Like the spindly blue lines—spikes.
Realize I must look more critically at my work.
Evaluate color, line, form, paint, surface.
Tensions. Composition. Bottom left corner
is quieter now. Leaf forms disappear.
Strong verticals of blue lines. Area in mid-left
is confused—"Touch" is about reaching.

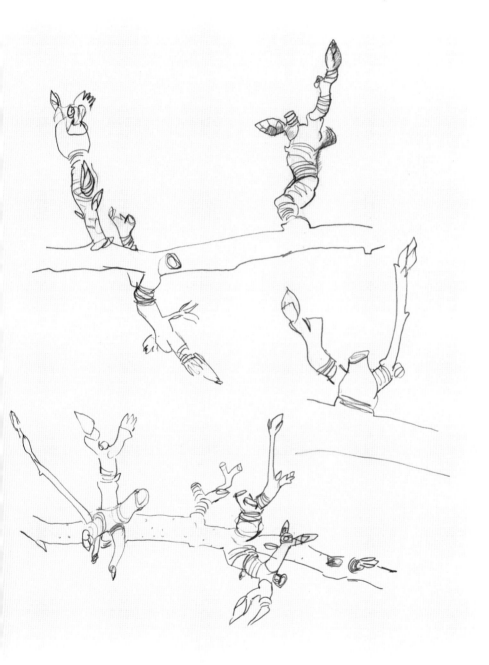

THORNY PROBLEMS

A neck injury forced me to lie patiently on my back for several weeks while the pain diminished. An alarming numbness in my right hand prevented me from holding even a fork, much less a pencil or brush, and I panicked. My mind fabricated scenarios in which I was never able to paint again. Once I was able to stand up for about thirty minutes at a stretch, I visited my studio but was completely defeated by the large oil paintings in various stages of finish. In a burst of determination, I tacked several sheets of paper to the wall. From the garden, I selected a few blossoms, sticks, fallen leaves, bark, and pebbles. I placed these on small white foamcore palettes in combinations that pleased me. I focused on color, texture, and shape. Then, using each palette as a starting point, I carefully mixed my paint to match nature's colors as closely as possible and began to paint on the paper with a few direct strokes. The paintings are simple and spare, fresh and promising, and much less finished than my usual work. The limits set by my temporarily impaired physical abilities demanded a resolution that never would have emerged had I been able to tackle my larger paintings.

I was so preoccupied with my pain and recovery that I forgot to cut back the boysenberry vines. Each season, in the late summer, the rods that have borne fruit should be cut back to force new growth into the laterals, which will bear fruit the next year. Once I had reentered a normal life, I remembered the neglected vines, but kept putting off the task. It was early winter before I finally confronted the berry bed, armored with thick leather gloves and a long-sleeved denim shirt. The vines are covered with wirelike

thorns and bristling hairs that prickle and burn when they lodge in the skin. Even with my precautions, I got pricks on my face and through the fabric of my gloves and shirt.

I was unsure which vines had borne fruit the season before and which were the new laterals preparing to blossom and bear fruit this year. By now, the vines were interwoven and bare of fruit; they all looked the same to me. I snipped them back to five feet, then assessed the situation. I still couldn't distinguish last season's rods from the new laterals. Our landlord had once told me that he simply cut everything back to the ground in the late summer and always had a good berry crop, so I cut some more. Then in a "What have I got to lose?" experimental frenzy, I cut all the vines back to about eight inches from the ground. I regretted it immediately. I didn't see how they could possibly grow long enough over the next few months to produce a good berry crop by July.

My rash act nagged at me. The berry bed is adjacent to the rose bed. (I'd put all my thorny problems together.) As I learned to prune the roses, I had the berry vines in sight. I very much wanted fruit next summer to pick for baking and to eat fresh off the vine, but it looked like I'd ruined the boysenberries for this season. Their pathetic short stalks stuck out of the ground. I visited my friend Shepherd, who cultivates boysenberries commercially. It didn't help my sense of failure to see his vines, looping over wires that held them

off the ground, lush with leaves and many yards long.

In early May, I borrowed a friend's truck to pick up a load of "mango mulch," a snazzy fertilizer/ compost with three kinds of manure and rice hulls. I shoveled it onto the berry bed and patted it down around the plants, offering the vines my apologies and encouragement. I watered faithfully once the late spring rains ended. The shorn vines are still too short for the season, but they are thick with foliage and white flowers. Centered within the petals are the green beginnings of berries. I'm relieved I will have a decent crop.

Pain and sticky problems precede discovery and growth. Cutting back and being willing to detach from the known while waiting for the unknown to materialize are part of the creative process. The payoff comes in many forms, unpredictably. My neck pain last summer forced me into a reckoning with the aging process; I've made a pact with my body to take care of it and stay flexible and strong. The paper paintings are harbingers of some-thing yet to materialize fully in my work. I've incorporated the use of garden palettes into my painting process. And I'm planning our "Mmm! Berry Pie Party" for early July when the boysenberry vines, having forgiven me for my impulsiveness, will be laden with fruit.

Pain and sticky problems precede discovery and growth. Cutting back
and being willing to sometimes painfully detach from the known
while waiting for the unknown to materialize
are part of the creative process.

GROWING TOWARD THE LIGHT

The first improvement we undertook after moving into our country house was converting the detached three-car garage into my painting studio. Our friend Ken, an accomplished photographer and craftsman, renovated part of the garage to make a light-filled studio with north-facing windows and an east-facing sliding glass door. But the door opened onto an overgrown hedge that occupied an area about eight by fourteen feet. Having been allowed to grow for years untended, the hedge created a screen that obscured the view of the neighbors beyond our back field. It supported a wall of ivy growing up its backside. By trimming some of the hedge, I hoped to clear a space for a small porch.

After I began clipping the greenery, I realized that all the leaves grew toward the outside few inches of the branches. Once the leaves were cut off, only a mass of woody stems remained. I decided to take out the whole hedge and sacrifice the privacy it provided. A proliferation of waxy green leaves seemed to be growing from the top of the hedge's dense, bare branches. Intrigued, I clipped and sawed more furiously to see what was hidden. Finally, my efforts revealed a wonderfully gnarled tree trunk and knotted branches belonging to the waxy leaves. For so many years this tree had struggled to find a way to grow toward the light and had survived in a delightfully convoluted form, not deterred by the hedge that surrounded it or the ivy that intertwined its branches and tried to choke it from behind.

My father came to visit and together we chopped away the rest of the hedge. Despite afternoon temperatures of a hundred degrees, my seventy-five-year-old dad went to work building a deck in the cleared space. The tree now frames the deck, still providing privacy but filtering light and sky through its leaves. Its beautifully knotted and looped branches greet me at my studio entrance, a reminder of tenacity and the will to overcome obstacles. If it could talk, the tree would say, "Look for the light and grow toward it."

CELEBRATING THE BOUNTY

Come clean with a child heart.
Laugh as peaches in the summer wind.
Let rain on a house roof be a song.
Let the writing on your face
 be a smell of apple orchards in late June.

CARL SANDBURG

JULIA'S JUST JOEY

The Just Joey roses have blossomed. I am crazy for their color. The outer petals are a pale peach pink with just a touch of yellow—delicate like a baby's skin. As the petals swirl toward the center, the peach color intensifies. Perhaps it is closer to a cantaloupe, but it is not truly the color of any fruit, vegetable, or anything I know. In paint, it would be approximated by red cadmium scarlet and cadmium orange mixed together with white. And then it would be entirely unsatisfactory. To paint the rose would only be a frustration, so I just drink in the color. I have seen this color in nature before at that moment when the sun is low and across the horizon is a band of color—not quite orange, not quite gold, softly pink but more intense, set off by white clouds, blue sky, and gray-green ocean. Trying to capture something so free as light results in the impossible, or worse—the corny. Like the sunset, this rose is too pretty to paint.

I have Julia to thank for this little bush. She knows me well and so gave me this gift of my favorite color for my country garden. I think roses were put here on earth to teach us to look and to love beauty. They remind me that something beautiful is enough in itself. I have been given roses before, cut, long-stem, in vases or boxes. Gifts of love and admiration or, on occasion, repentance. Julia's present enriches my life and comes with no strings attached. She was one of my first gardener friends and gently tended my urban garden whenever I was away. Here in the country, this unpretentious bush with its remarkable color reminds me of Julia's good nature and generosity. It grows and blooms in all its loveliness for no other reason than it must and can. Intense at first bloom, it will

fade to a creamy white with only a hint of peach. Tomorrow the color will be washed away and the outer petals will show signs of wilting. I am glad I'm here today and can take time to see the colors.

Studying the rose, I realize now what makes its color so lovely and rich. It is the overcast sky. The sun is packed away behind layers of soft, gray clouds. The diffused light keeps the background foliage a deep, dull green and lets the peachy rose take center stage. There are no harsh shadows. I also realize that as much as I'd like to be, I am really not completely content with the moment. I always want something to hold on to—a record that I existed and saw and experienced. I've given up trying to photograph pre-dictable postcard memories like Greek doorways and sunsets, but I still want to record this rose in paint or words. The desire to put something seen or felt into tangible form is the artist's drive. It can't be denied. I go to the studio to get my watercolors, return to the rose, and paint it.

The artist's desire to put something seen or felt
into tangible form cannot be denied.

KIMI'S BEAN HOUSE

imi, a talented choreographer, grows delightful gardens. She makes apricot-toned tulips march in rows, sweet peas rise gracefully in arcs, tomatoes stand and stretch out wide, and wildflowers weave merrily in and out of planting beds in a profusion of color. One day, a decade ago, I joined Kimi for a lunch of fresh green beans and tomatoes in her garden. Just outside her bedroom window, an arched trellis supported a leafy profusion of beans, a canopy of green inviting us into a hollow dappled with light and shadow. The gated entrance to her garden could be reached by a circuitous route from her basement through the alley next to her apartment building, but it was easier to climb out the bedroom window. We bowed low to enter into the bean tunnel and stepped out into her sunny colorful garden. At a small table set up in a flower bed, the delicious meal offered me a taste of something I wanted in my own life—sun, color, earth, and nourishment from the garden. The next day back in my studio I began a large abstract painting that I titled "Bean Heaven." It served as a talisman for several years until I moved out of my apartment and claimed my own little urban garden.

The summer that her daughter, Maya, turned two, Kimi planted a bean house. She built a bamboo-and-string frame house with a peaked roof, a vestibule, and a window. All along the perimeter she planted beans, and tucked in tiny violets near the front entrance. As the vines grew, she gently wrapped their

tendrils around the strings so the plants would grow to cover the house. By July the house was fully covered—a fantasy home growing toward the sky, a magical place for a child. It was Jack's beanstalk, a fairy hut, and the enchanted forest all rolled into one. Quinn and Maya played together, running in and out, peeking from the doorway and window. Kimi and Maya celebrated their house with tea parties on sunny summer afternoons. They picked the beans for lunch and dinner, breakfast and snacks.

The bean house fully captured my imagination and the image has stayed with me for years. Discussing it with other artists, the questions surface: Does art lie in the making of something or in the consuming? If only a few people see it, is its artistry less meaningful? If its intention is not art but a playful backyard experiment, is it still art? I believe that art comes through transformation, taking materials and changing them into something that deeply touches the soul. Kimi's bean house touched mine. Existing for only a few weeks, the bean house carved out a space in the air and light of the garden—a presence sure and magical. Photos and drawings to prove its existence don't provide the experience. What I hoped to capture about it in paint I have not yet been able to do and may never do. But the bean house remains in my memory and in my heart. It's a testament to a way of making art that has as its intent and its fulfillment an embodiment of a joyful spirit.

When materials have been changed into something that touches the soul deeply, we witness the transformative power of art.

117

The bees are busy today. Lots of them.
They alight, dip into the blossom's center
and move on. If the flower is spent or if they have
drunk the nectar, they quickly move on.
When they first alight they crawl across the petals—
getting into a good position to drink. They seem
to have no memory—drinking—moving on—then
alighting again on a flower they have already visited.
They waste no time—they can tell there is nothing there.
So they move on. They stay longer on some blossoms
than others—the juicier ones. Learn from the bees
to land lightly—test it out—explore it—drink deeply from it.
To know in an instant when I've been somewhere before
and need to move on.

really xx
now they
grow

hairy parts of flower
become hairs on berries

SHOWING YOUR STUFF

Walking through the garden one morning, I am delighted to see a clump of reticulated irises popping out their purple heads. They didn't bloom the season before, our first spring in the house, so their presence in the garden takes me by surprise. Nearby, tiny violets emerge from the baby's tears. If I hadn't looked down, I would have missed them. A fragrance fills the air. I smell the lilacs before I see the bush has bloomed. At every turn, in every season, the garden unabashedly shows its stuff.

Asking for attention is part of the creative process. "Blow your own horn," my mother used to say as a way of encouraging me. I still don't like making a big noise, but I've become more comfortable asking others to celebrate with me an exhibition of new paintings. My invitations to openings are sent in the spirit of a gift, not an obligation. The paintings make their debuts as part of their life cycle. They may be purchased from the exhibition and find a new home on someone else's wall or they may return to my walls and storage shelves, but first they need to be seen and considered by other eyes. No matter how emotionally connected I am to the work, there comes a time when in order to keep on painting, I must send the paintings out from the studio and display them.

The garden is quietly showy. The roses bloom even when I go on vacation and am not around to exclaim over them, but their beauty fades in a few days. The camellia bushes

erupt in magenta and white, a performance that goes on for weeks. Then as an encore, they carpet the garden with fallen petals. The wildflowers ask to be noticed, too, waving their pale violets and yellows in the field before disappearing under the mower.

Like the luscious rose or the delicate wildflower, we're each entitled to our moments of glory. We can enjoy the attention our creative endeavors bring us, knowing it won't last. Whether inviting hundreds to an opening or showing a painting to a friend, publishing a book or asking a writer you just met to read a final draft, there are many ways to celebrate the work. In sharing, the work comes into its own. The creator can step back and view her efforts with a fresh perspective. Soon enough, the party's over and new work beckons. The sweet fragrance of the flowering lingers. In the creative cycle, things will bloom again.

Sharing our creative endeavors honors the work and gives it a life of its own.

LETTING GO

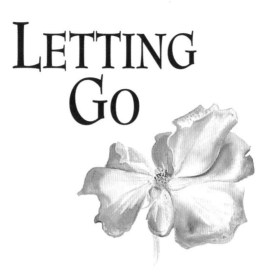

There were the roses, in the rain.
Don't cut them, I pleaded.
 They won't last, she said.
But they're so beautiful
 where they are.
Agh, we were all beautiful once, she
 said,
and cut them and gave them to me
 in my hand.

WILLIAM CARLOS WILLIAMS

BURNING THE BRUSH PILE

The pile of discarded garden and tree trimmings, already a substantial mound when we moved in, was an eyesore that threatened to take over the field at the rear of our property. It encroached on the children's games of baseball and capture-the-flag. But I became obsessed by its form and contents. I retrieved sticks from its depths for use in making paintings and I frequently drew its interwoven branches in my sketchbooks. It arose in conversations. When I told people I was painting my garden, they always acted interested. But when I mentioned my attraction to the brush pile, they backed away visibly, thinking, "This woman has too much time on her hands. She's gone over the edge."

The seduction of the brush pile was easy for me to understand: I've always loved sticks. On trees, in piles, lying at random on the ground, branches and twigs appeared to me as nature's gestural dance, like traces of a dancer's arm carving through space. My drawings of the brush pile were just lines, sketched quickly and as freely as possible, an antidote to the realism that had governed my work for the past several years. The painter Philip Guston said, "The difficulties begin when you understand what it is that the soul will not permit the hand to make." I'd been struggling with those soul restrictions, but my hand now sought the brush pile as a bridge to somewhere, although I didn't know where I was heading. As the arcs of the branches guided my pencil and brush, I felt I was being released from my reliance on realism.

One morning, when I returned from driving Quinn to school, the brush pile was in flames. Ralph, a local orchard worker whom I had called weeks before, had finally shown up to burn it. A county ordinance prohibits burning after a certain date, which was approaching. Now I discovered the extent of my attachment to the pile. I dashed into the studio, grabbed my sketchbook, and hurried out to the field. As Ralph and his assistant doused the pile with gasoline and fanned the flames, I sketched. Smoke stung my eyes, but I continued to draw blindly. Fire tunneled through the mound of branches, carving out red, glowing caves. I drew furiously. The first drawings were dense, confused. Gradually, they cleared out. I isolated a few lines in the pile of branches and committed them to paper. I drew for several hours as the brush dissolved into a carpet of gray ash with only a metal pipe and charred tin can jutting forth.

The fire wrenched me out of my devotion to the brush pile as subject matter. Without it to shape my work, I am, for now, as free and formless as smoke. The pile's dense layering and lyrical lines guided my hand and brought me closer to finding what I have been searching for in my work. There is still something I want to see in my paintings that hasn't yet made its way to canvas and stayed. It's in me. I recognize it in the colors of the garden and the small pile of sticks mounded in the corner of my studio.

After letting go, before finding new attachments,
there's a time of being free and formless.

VOLUNTEERS

I t's all compost now," Dennis counsels me. I'm having a difficult time letting go of a grudge. I feel we've been the victims of greed and neglect in some business dealings and that we've been treated unfairly. The momentum we've spent years building in our children's music business has come to a halt and there is no creative thrust, only legal maneuverings, waiting, and debt to pay. Relationships that had seemed fruitful have turned sour and not yielded their promised abundance. It's not only the lack of financial rewards I lament; I grieve that our songs, which have delighted so many children, are currently silenced—a casualty of corporate shuffling.

I dig in the compost to work off my frustrations. Shoveling away the top layer of recently tossed garbage reveals a dark brown sludge; it is all that remains of our daily feasts. Thousands of worms squirm in the mud, which oozes something orange—the rinds from morning juice, last fall's pumpkins? Organic matter returns to itself. As I harvest the compost, sifting the freshly brewed earth through a screen, I think about disappointments. I've often sent slides to galleries and juried shows and met rejection. In personal matters and in business, a few very important promises have been broken. Then I picture the paintings in my first solo museum show last summer. They achieved what I had hoped for by creating a colorful, distinctive garden environment within the gallery. I think about our friends' children who sing our songs. Recalling their joy helps to diminish our business problems.

The sun warms my skin and the orange blossoms freshen the air. For now, the disappointments seem insignificant and far removed. Nothing essential has been taken. The deep place from which I work is untouched. Where the songs came from, there are more. The paintings are traces of my time spent in front of the canvas. I have more time. The painter sings in me and has never been silenced by acceptance or rejection.

The shovel scoops up a sprouted potato, a young tomato plant, and a scraggly zucchini. These volunteers from the compost are ready for planting. A peaceful feeling envelops me as I dig and sift. Tomorrow I will clear out the vegetable bed and work the fresh compost into the soil, then I'll attend to some business matters. But today, I'll bring my watercolors into the garden and listen to the birds' song resonate with my own.

Acceptance or rejection cannot touch that deep place from which we work.

MOVING BOUNDARIES

Gardens tease us into believing we can tame and control nature. We carve out spaces for plant life as if to say, "You belong here. Stay put. Grow beautifully." It's like getting a one-year-old to do your bidding. When he learns to crawl, you put the safety gates up. For a few months, you stop having the nightmares about your baby falling down the stairs. Then he learns to climb.

The safety gates of gardens are built of wood and stone, brick and cement, gravel, chipped bark, and weed cloth. They function well for a few seasons or decades, then nature takes back its own. Wood is devoured by termites and cement walls split open where roots have found a foothold. As this country garden has evolved, many gardeners have left their imprint. I am slowly leaving mine.

Edges give gardens structure, which is pleasing to the eye and helpful to the gardener. A wall of shrubs next to the house serves as a backdrop for colorful foliage and keeps the weeds and dirt away from the foundation. Wooden lath follows the curves of a brick path and prevents the dirt from spilling underfoot. Trellises and fences support climbing plants and provide visual barriers, defining outdoor rooms and private spaces. Concrete walls, rocks, and railroad ties divide the garden into manageable sections, create levels of different height, and keep earth from tumbling down hillsides. As I have become more knowledgeable about boundaries in the garden, I have become more respectful of them in my life. They help me see what I have and what

I have to do, who I am and what matters to me. There is a great freedom in being an artist, but flexible restraint is necessary to give freedom focus and support.

One day I discovered that the railroad ties hemming in the beds near the orange trees had been eaten away by termites. They looked secure in their place until I snagged the hose on one and yanked, pulling the shell of wood away from its sawdust core. The choice presents itself. Do I get more wood and place it around the bed in the same configuration or seize the moment and change the shape of the garden? I think about rocks. They will not crumble over my lifetime; they can be placed in a variety of configurations; and I love them.

My friend Carla, an artist who creates with willow, lives near St. Elmo Creek in a mountainous, wooded terrain a forty-minute drive north of my home. The creek rushes violently during the winter and spring. In the summer, when the creek slows to a trickle and stops flowing altogether, I meet Carla there with my watercolors to paint the logjams left by the winter's deluge. Water stands in pools among rocks here and there. Huge boulders are exposed. Tree trunks and branches thrust by the raging water are crammed at all angles into crevices between boulders. They form knots and massive tangles that deny on this summer's afternoon that they could ever be budged. But when the river gathers momentum again next winter, the multi-ton boulders

will roll through the water like peas being washed off a plate. The logjams will be tossed by the water as lightly as matchsticks to be broken into bits or jammed into another bank and lodged, setting up snares for new jams.

Every time I visit the creek, I wish I could bring a few boulders back to my garden. But they are inaccessible, so I have set my sights on less imposing stones that litter the road down to the creek. Many seem small in comparison to the gigantic ones in the creek bed, but they are still too heavy to lift. I choose ones I can carry to the car and bring them back to the garden, where I am slowly transforming some beds from timber-bordered to rock-edged. I also place the stones here and there in the beds. Their presence adds dignity to the garden.

When I began the project, I wanted to complete the new borders quickly. But the excursions to gather the stones take time and my future holds many painting excursions to Carla's creek. There is no hurry. Thanks to my sister Robin and her husband, Rick, who have generously loaned us the down payment for our property, I will be tending this garden for the next decade.

I move the rocks around, considering their proper place in the garden. In a similar way, we set boundaries for our work and relationships. We put up walls with the stones of our experience, then reconfigure them. Some stones spring loose of their

own volition. Others need to be moved, but are too heavy to lift without help. At times, we pile them too high and they topple over. Some are too small to make a sturdy edge. Others are just the right size to form the distinctions we need. Creative work asks that at times we form around ourselves a circle of stones that excludes distractions. At other times, it asks that we scatter the stones, opening the circle wide to whatever might wander in. We can shape our boundaries in any design, as we learn what suits us.

The soft stone colors in the garden—gray, beige, black, salmon, rust, silver, and white—contrast beautifully with the foliage. Long after I leave this place, years after many of the plants here have died, the rocks will remain. They will carry their history forward without me, and will doubtless be moved around by future gardeners making their mark on this little plot of land.

Flexible restraint gives artistic freedom focus and support.

We shape our own boundaries.

*In all seasons, we may grow bountiful gardens to contemplate
in solitude and celebrate in friendship with one another.*

Acknowledgments

There are so many people whose friendship, questions, comments, encouragement, talents, and generosity of spirit have contributed to *A Painter's Garden*. In particular, I would like to thank Cathy Kouts, Susan Bercu, Lynn Bell, and Linda Hauck for helping me shape this book ❧ my editor Amye Dyer and others at Warner Books for their expertise and enthusiasm ❧ Kimi Okada, Julia Thompson, Patti Dobrowolski, Jeanie Makanna, Margaret Thomas, Lelé Santill, and Sarah Alexander for their guidance on the journey into gardening ❧ fellow travelers Maureen McGowan, Carol Prince, Rosa Malone, and Pam McCosker for sharing dreams and making lists ❧ Linda Woodsmall, Carla Thistle, Margareta Bancroft, Ellie Coppola, Arlene Bernstein, Rene Stark, Nancy Stark, Sally Dawson, ML White, Peggy Stringer, Liz Walters, Carol Koffel, Patti Trimble, and Shepherd Bliss for reading essay drafts and offering encouragement ❧ Gerard Perusse, Michael Meyers, Jeri Marlowe, Greg Schelkun, Gina Colombatto, Carla Emil, and Amy Pertschuk for their questions along the path which led to this book ❧ Brenda Way, Katie Nelson, and Kimi Okada, for their gift of dance which has influenced my work.❧ I am also deeply appreciative of all those who have encouraged my painting through their patronage and efforts to have my work exhibited, in particular Michelene Stankus, Kat Taylor, and Peggy Harman. ❧ Finally, for their love and support throughout all seasons, I am grateful to my family: my parents, Bob and Ramona Walker; my siblings, Carol Dobbs, Robin Walker-Lee, and Lloyd Walker and their families; my husband and creative partner, Dennis Hysom; and our son, Quinn Walker Hysom.

Plates

Photographed by Kevin Duggan, Jacques Cressaty,
Richard Lloyd, Ming Louie, and Michael Smith.

Woods #2, oil on paper; all other paintings, oil on canvas.

10/5—

The trees wanting something nice from them — still thinking of large garden... landscapes beyond the wall + abandoned gardens, —

Suggestions of growth — real to abstract — things coming into being — into focus — others, other things just suggested

Feel a line — however thin — connecting me to something. Something in me to be pulled out — something deep connecting to the open, expansive — full if clear, bright, joy. My "subject matter" is always a problem. I keep coming up against it. Why do I paint what I paint, what is it, what does it mean? What value does it have? In the end the subject matter doesn't matter much — or does it. I am struggling now — wanting to be open — easy, who — but am judging myself, censoring + scrutinizing every step of the way. roses are too mundane or easy — or are they. Perhaps they will be perceived as mundane. But what are they to me? Beauty. The joy of looking, seeing, noticing, watching unfold. Do these paintings say that. They too realistic? Not realistic enough.